TRURO
THEN & NOW
IN COLOUR

CHRISTINE PARNELL

The
History
Press

First published in 2012

The History Press
The Mill, Brimscombe Port
Stroud, Gloucestershire, GL5 2QG
www.thehistorypress.co.uk

British Library Cataloguing in Publication Data.
A catalogue record for this book is available from the British Library.

ISBN 978 0 7524 8106 7

Typesetting and origination by The History Press
Printed in India.
Manufacturing managed by Jellyfish Print Solutions Ltd

CONTENTS

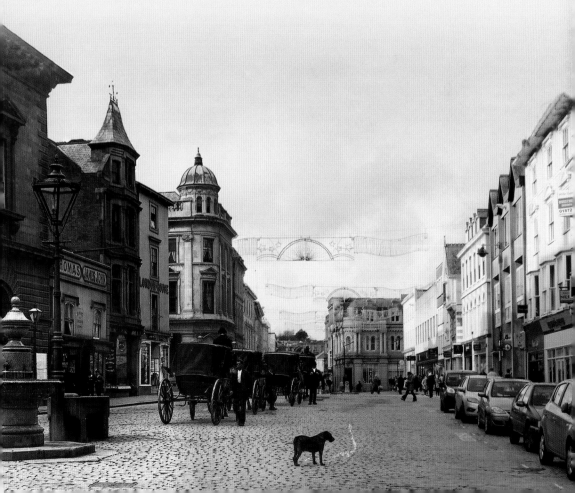

ACKNOWLEDGEMENTS

My thanks go to everyone who let me borrow their treasured photographs for *Then & Now: Truro* back in 2001. Some of those photos have been used again in this book. I must also thank Sandra Alsept (née Luck) for her contributions, and Vaughan Magor for his Army Cadet picture. Thanks also to my cousin Graham Coad for his help and knowledge.

ABOUT THE AUTHOR

This is Christine Parnell's tenth book on Truro and the surrounding area to date. She has been interested in local history from an early age, and currently works in the Cornwall Registration Service. Christine has been secretary of the Truro Old Cornwall Society for sixteen years.

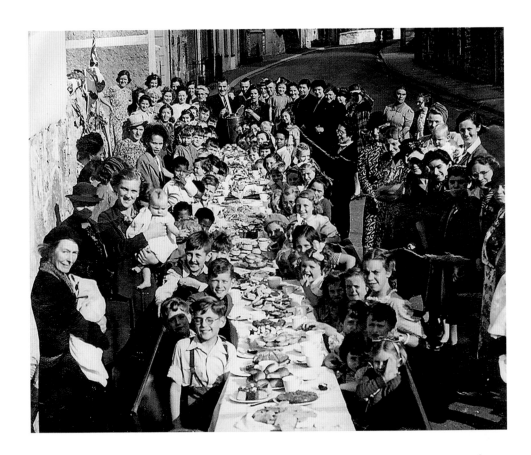

INTRODUCTION

When I was asked to update the 'Then & Now' collection I wrote in 2001, I was delighted. At that time the changes in Truro were happening so quickly that I knew that many of the 'now' photos would already be out of date by the time the book was published. In fact, the changes are still occurring, as one would expect in any town – but at the moment, because of the recession, it is more a case of familiar businesses disappearing, rather than new buildings and roads appearing.

It is so difficult to remember what a place used to look like once changes have been made, and hopefully to take a nostalgic look at Truro as it used to be will evoke many memories. It may also prove surprising – especially if the photographs are of somewhere we pass by regularly but never really notice. Although we have lost many of our old and unique buildings, the city still has plenty of character, but we need to take care of what we have left. I also think that Truro looks much brighter these days without the layer of soot deposited by many cottage chimneys. This is partly due to cleaner fuel, and partly to the fact that so many of the cottages that were crowded into Truro are gone. Many of those that are left, such as the ones in Castle Street, are now offices.

Another factor that brightens up the town is the amount of trees and flowers we have everywhere. The parks department of the city council regularly enter the Britain in Bloom competition and always do well. No special effort is made before the visit of the judges: the town is always like this. What once was the city dump on the road to Malpas is now Boscawen Park, with beautiful flowers in summer, trees and a play area for children, an outdoor stage and a riverside walk that also skirts the cricket ground. There is a coffee shop by the tennis courts that is always popular. On the other side of the road, parents struggle to keep hold of their offspring as they throw food to the swans and ducks. On the other side of town, Victoria Gardens was opened to celebrate the Diamond Jubilee of Queen Victoria, and close by are the Dreadnought playing fields and Waterfall Gardens. No wonder Truro is such a lovely place in which to live.

Will I be asked, in the future, to put together another wander down memory lane? I hope so.

Christine Parnell, 2012

Opposite: The turnout for the street party held to celebrate Victory Over Japan Day in 1946 shows what a community lived there. The only name given in this photograph is that of Mrs Emma Solomon, the white-haired lady seated back left. She and her husband Charlie were the landlords of the Navy Arms in Fairmantle Street for many years, from 1924 to 1959.

HIGH CROSS

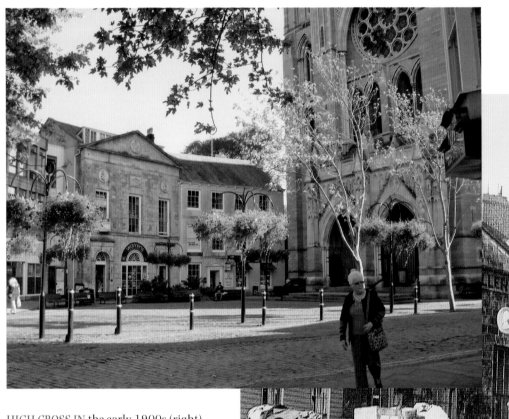

HIGH CROSS IN the early 1900s (right), crowded with the horse buses that came in regularly from the country. One covered the Summercourt and St Columb area. All the buses are loaded with parcels: the one for St Columb even has a bicycle on top. When this photograph was taken, Burton's was still housed in the old Assembly Rooms, which opened in around 1789 and closed when the new Palace Building took over as the Assembly Rooms. Despite the layer of soot, the Wedgewood plaques stand out. Burton's China Galleries later moved premises to King Street, opposite the cathedral, and 'Burton' can be seen on the brickwork of the new building there.

THIS ATTRACTIVE AREA, outside the west door of the cathedral, is known as High Cross because the old cross, a way marker and preaching point, was known to have been located here at least 700 years ago. Although it was lost for many years, having been buried in St Nicholas Street, the top section of the cross was found during road works in the 1950s and re-erected on a new shaft in the 1990s. In the past there was a large flowerbed in this area, but it was removed prior to a royal visit – and the cobbles that surrounded it were covered over to protect the Queen's ankles! Today, trees and hanging baskets make this a pleasant place. Charity stalls and fêtes use the area, and processions to the cathedral pass this way.

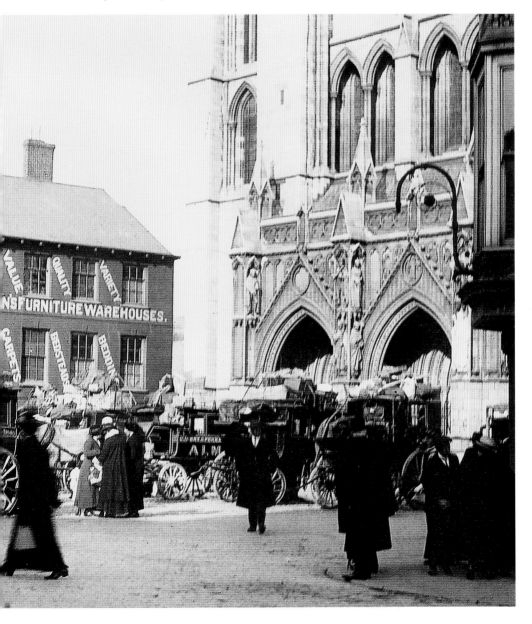

KING STREET

KING STREET IN around 1920 was just as much a shopping street as it is today. The tailor's shop belonged to John Osborne. Eastmans, a butcher's shop, was still there in the 1960s, when it became Dewhurst's. G.H. Philp, the photographer, is to be thanked for many of the old views of the town that survive today. His postcards are now collector's items. This part of King Street is very close to High Cross, believed to be the oldest part of Truro. Traders or pilgrims crossing from the Gannel

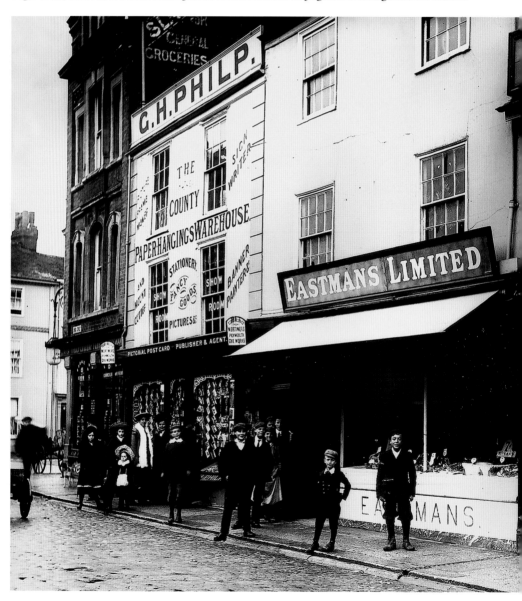

to the Fal would come into Truro from the Pydar Street direction, and the town is thought to have grown up around the cross: Cornish historian Charles Henderson suggested that the cross is in fact older than Truro itself.

KING STREET IS still a busy shopping area of town today, although all the shops in the early photograph have gone. The photographer G.H. Philp's shop used to be covered in writing but is much neater today, with plain walls. It has lost the pediment and also has smaller windows. A charity shop occupies the store now and Eastmans, who were in King Street for many years, is now occupied by Whittard's, where one can purchase tea, coffee, and all sorts of attractive crockery in which to enjoy it. As this street joins Boscawen Street and Pydar Street it is quite a busy thoroughfare, but it was previously believed to be just a part of Pydar Street. In 1700 it was known as 'High Street' but was referred to as King Street in a deed of 1797.

PYDAR STREET

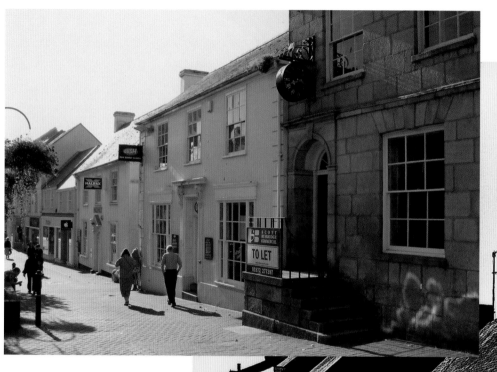

PYDAR STREET IS one of the most ancient routes leading to the town and was referred to in 1464 as Strete Pydar. It takes its name from the old Hundred of Pydar and leads out to Pydar from Truro. Truro is in the Hundred of Powder. Many of the properties are old: if you go to Pydar Street and look at No. 7, currently an Orange phone shop, you'll see a façade that is more or less as it would have been in the early part of the 1600s. The properties have an interesting variety of styles, and it is obvious that there was no town planning in those days – but the overall effect is full of character.

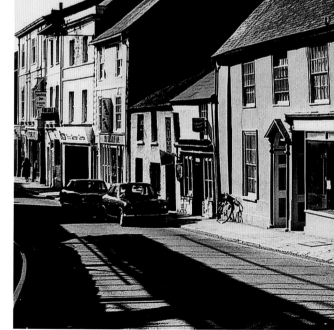

IN THE PHOTOGRAPH of today we see the same properties spruced up and looking quite smart. Unfortunately, all the old houses on the other side of the road have been demolished, including The Armoury and the London Inn. These days, thanks to Lush, the aroma of exotic candles fills the air, but in years past the lane beside Pydar Street led to a tannery, so the smells would have been very unpleasant. It is still known as Tanyard Court. Several prominent townspeople lived in Pydar Street at this time and did not seem to mind their upper-class properties being so close to the tanning yard.

NO. 108, KENWYN STREET

IN THE 1920s, No. 108A Kenwyn Street was occupied by Mr Collins and his coach-building business. He is shown opposite, standing outside his shop, in around 1925: he is the man in the centre of the photograph, his staff either side of him. In the window he has displayed tyres for traps and jingles. He later moved to Bodmin and a Miss Osborne set up her grocery business in these premises. Just by No. 108, tucked away behind, was the home of a lovely Welsh lady called Mrs Penrose. Her door opened into the blacksmith's yard, and the men there agreed that they would not do anything involving lots of smoke when she had her washing out! Their reward, on a Friday, was a plate of freshly made Welsh cakes.

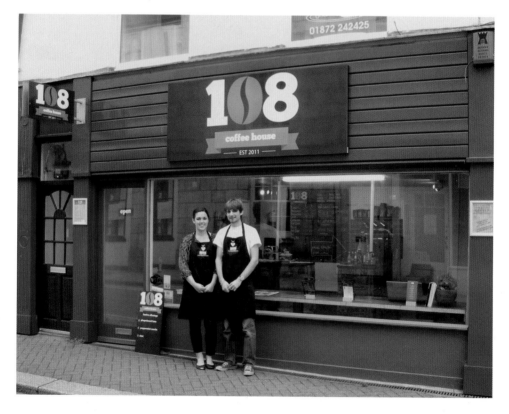

THE NUMBERING SYSTEM of Kenwyn Street was changed in later years and the same shop is now 108. The previous No. 108 was the blacksmith's shop (F.W. Mitchell and Sons), tucked away just behind the street front, but they have been gone for many years. No. 108 is now the home of a very smart coffee house. Michelle O'Leary and Paul Jordan pose outside approximately ninety years after Mr Collins and his staff did the same. The shopping area around Kenwyn Street is now referred to as a 'specialist quarter', but as various shops come and go it is always worth a look to see what is on offer.

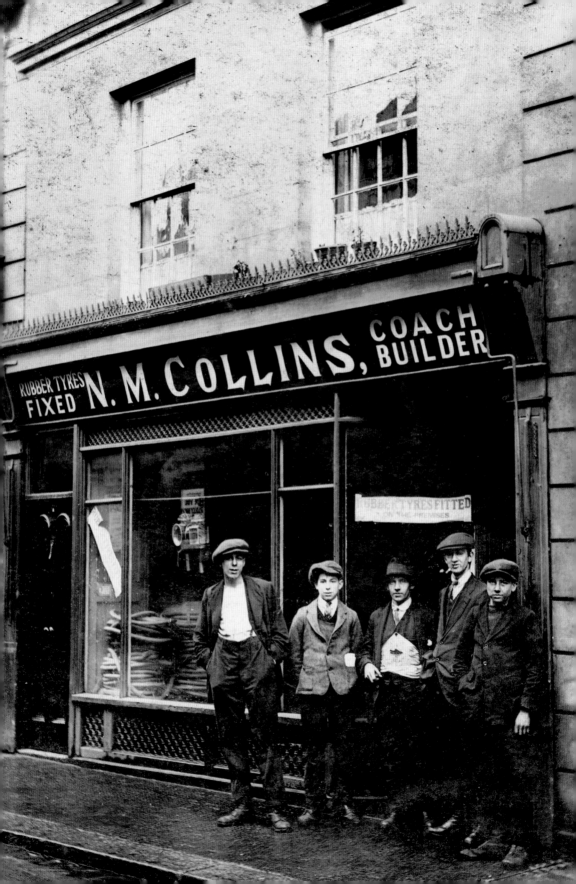

THE OLD POST OFFICE

ONE OF TRURO'S famous buildings was the unusually shaped post office in High Cross. It was built in 1886, and the architect was Silvanus Trevail (1851-1903), who was responsible for many important buildings in the county. It was, according to some, an inconvenient building to work in, with many corridors and small rooms, but nevertheless it was a sad day in June 1974 when it was demolished. The old Unicorn Inn had been knocked down to make way for it, as had the Brick House, owned by the borough. Brick House was unusual for Truro, where brick is not a common building material, and was sometimes known as 'the house by the cross'. The clock in the window of the post office was a handy alternative to the town clock to check the right time.

THE NEW BUILDING on the site of the post office was built for Marks & Spencer but they soon outgrew it and moved to Lemon Quay. These days it is occupied by a phone shop; this business used to have rather garish signs, but it now has signage that blends in with the surroundings. Another Silvanus Trevail building just creeps into the picture, the library in Pydar Street. The current post office, a modern construction, is just along from the site of the old one in High Cross, and the cross itself can be seen to the right of the tree.

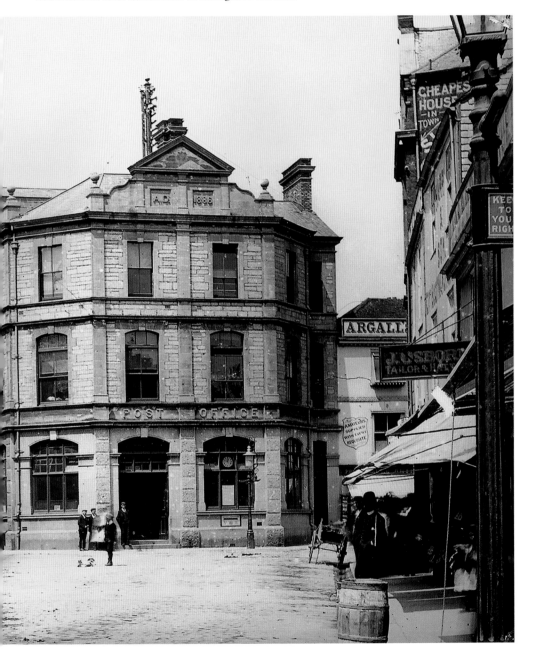

BOSCAWEN STREET

THESE PHOTOGRAPHS, EASILY recognisable as Boscawen Street, are very similar – but as far as the everyday lives of Truronians go, they are worlds apart. The earlier image is from around 1900, and shows cabs for hire standing in the middle of the street. A handcart is parked neatly at the kerb outside the Red Lion. Behind the horse trough is a shop selling cookers and gas fires, and next door are the dining rooms. The shop on the ground floor of London House appears to

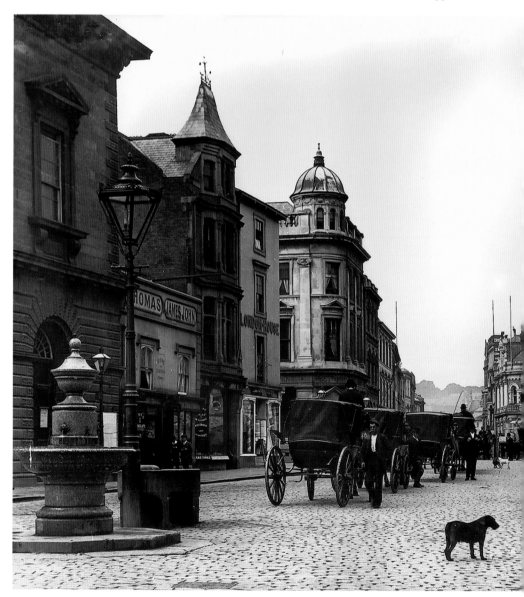

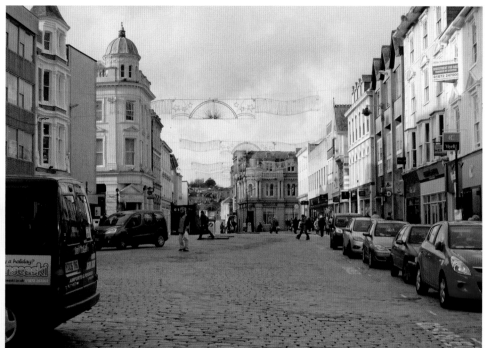

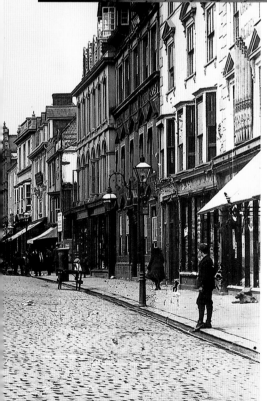

have rolls of carpet or linoleum in the window.
The sun blinds are out, and the windows of
the Red Lion's bedrooms are open – so it must
have been a pleasant day, even though the old
picture looks gloomy. These days the dogs would
not linger in the road as there is always traffic
passing through.

SO MUCH HAS changed in Boscawen Street
over the years, and yet so much is the same – the
street is still carrying on the commerce needed to
keep every community flourishing. The fountain
visible in the old view has long since been moved
to a place of honour near the bandstand in
Victoria Gardens and the horse trough has been
placed farther along the street and filled with
flowers. The Red Lion is no more: just the outline
of the Co-op grocery store reminds us of what we
have lost.

FROM GILL'S TO POUNDLAND

ALTHOUGH THE DATE of the old photograph is not known, judging by the clothes on sale in the window of Gill's it must have been taken in the early 1900s. Presumably there was quite a time delay for an exposure taken at lighting up time, and consequently many of the figures

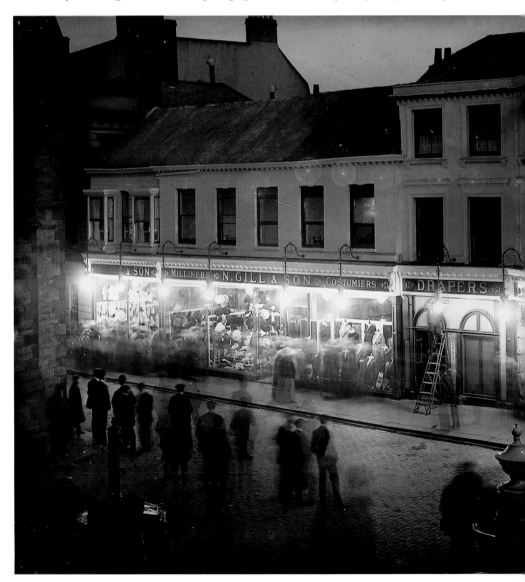

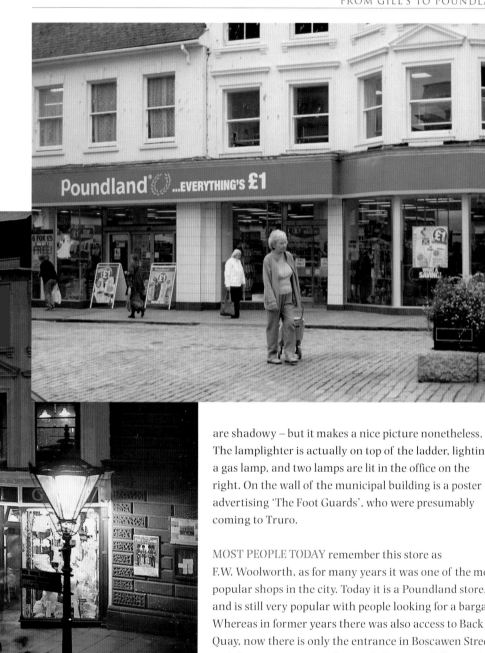

are shadowy – but it makes a nice picture nonetheless. The lamplighter is actually on top of the ladder, lighting a gas lamp, and two lamps are lit in the office on the right. On the wall of the municipal building is a poster advertising 'The Foot Guards', who were presumably coming to Truro.

MOST PEOPLE TODAY remember this store as F.W. Woolworth, as for many years it was one of the most popular shops in the city. Today it is a Poundland store, and is still very popular with people looking for a bargain. Whereas in former years there was also access to Back Quay, now there is only the entrance in Boscawen Street and the premises on Back Quay belong to a different shop. The granite setts that pave the road are clearly visible in this view. In some places they are a little uneven but they are so much a part of Truro that any attempt to remove them would cause an outcry. They have already been removed from some streets but they are part of the character of the town.

THE WAR MEMORIAL

TRURO IS VERY proud of its war memorial, which was unveiled on 15 October 1922 by the Lord Lieutenant of Cornwall, Mr J.C. Williams of Caerhays. This photograph shows the first Remembrance Day since the unveiling, with enough floral tributes to cover half the memorial. Heard & Sons' organ factory, N. Gill & Son's ladies' tailors and Jordan's printing works are in the background. The three spires of the cathedral (and part of the copper spire that housed the clock) can be seen in the background. This must have been a novel view for the people of Truro, who had only had a completed cathedral since 1910.

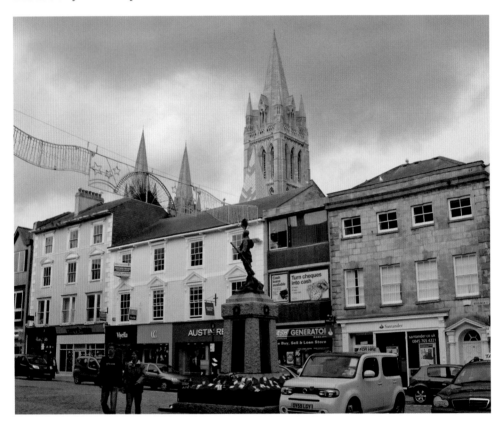

THE WAR MEMORIAL is still in pride of place in Boscawen Street and was caught in this photograph just after Remembrance Day, 2011. The shops and cafés on the opposite side are a far cry from Heard and Sons' and Jordan's printing works in the 1922 picture. Viyella, Country Casuals and Austin Reed have only just moved in to their new premises in Boscawen Street as the shops are constantly changing, but the Christmas lights are up in this photograph, and soon Father Christmas will be visiting Truro (as he always does) – and he will have real reindeer to pull his sleigh.

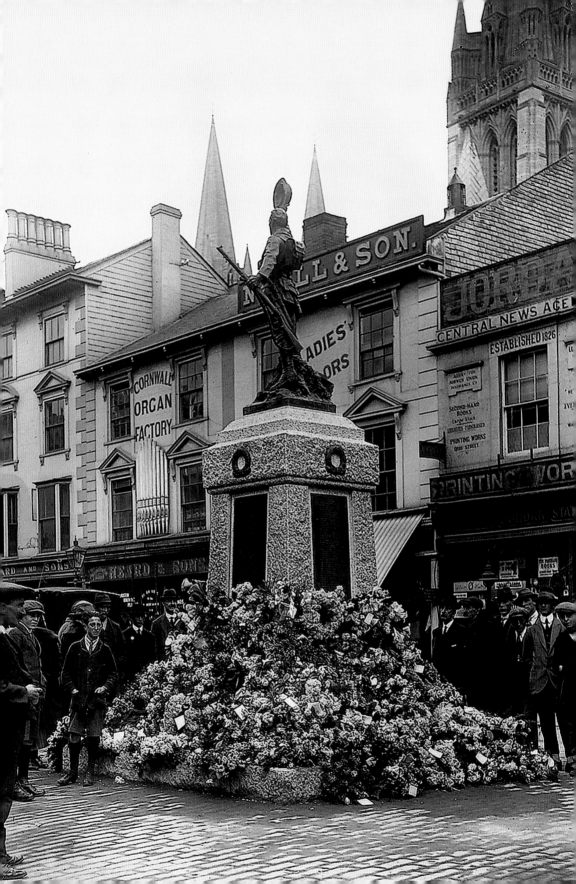

LONDON HOUSE

LONDON HOUSE IS on the corner of Lower Lemon Street with Boscawen Street and used to have a WHSmith on two floors with a library and reading room upstairs. Books could be borrowed at a charge of 3*d* each. The shop window extended round the corner into Lower Lemon Street. The earlier photograph is from the 1960s and was taken just as the modernisation of London House was beginning. The name 'London House' and all the windows on both sides were covered over with small white tiles that are still there today. Next door to London House was one of Truro's famous opeways (pronounced opways). It went from Boscawen Street to Back Quay and came out in the region of the Market Inn but it has been closed off for many years.

TODAY LONDON HOUSE has changed little and has had a travel agent housed on the ground floor for many years. Peter Boggia, who had his shop next door in the building with the fancy roof, has retired and a new occupier has moved in. A betting shop has also appeared in the middle of town. The opposite corner has been home to Lloyds Bank for many years but was once known as Vendal's Corner, after a drapery shop that stood on that site. It cannot be seen in the photograph, but there is water in The Leats. In the days when it was easier to park in town it was quite common to see visitors step from their cars straight into the water!

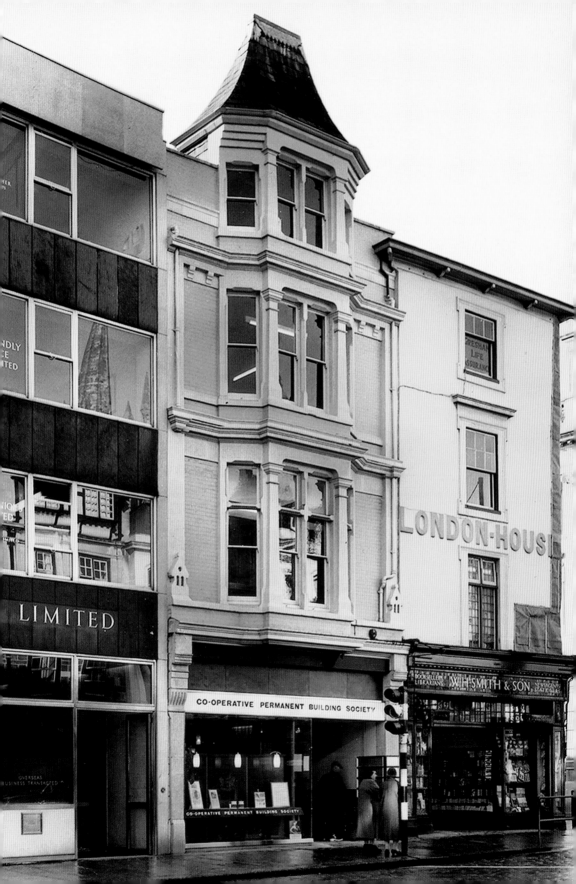

LOWER LEMON STREET

HENRY HODGE PULLS his handcart through Lower Lemon Street, possibly in 1910, when the town was decorated for the coronation of King George V. Henry worked for a brewery in Victoria Square. There are two cyclists in the street and a postman on foot with a large sack of letters. A pony and trap is waiting at the end of the road. The old fire badge can be seen on the Royal Hotel. Fire insurance was then paid to individual companies, and the badge showed which

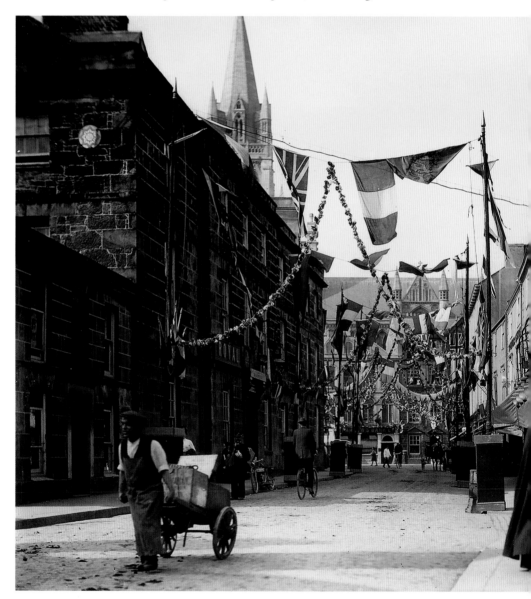

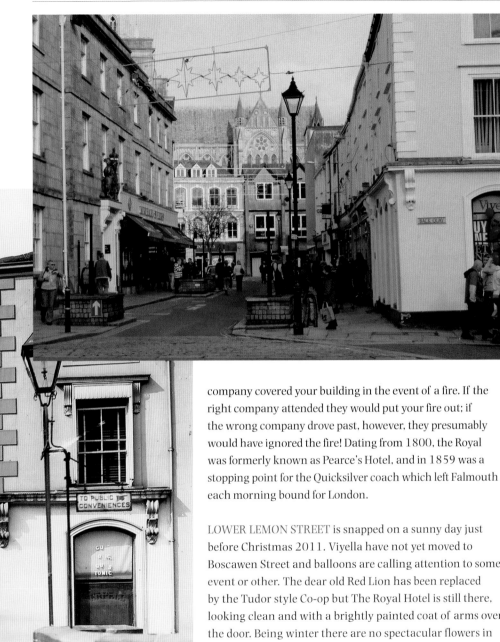

company covered your building in the event of a fire. If the right company attended they would put your fire out; if the wrong company drove past, however, they presumably would have ignored the fire! Dating from 1800, the Royal was formerly known as Pearce's Hotel, and in 1859 was a stopping point for the Quicksilver coach which left Falmouth each morning bound for London.

LOWER LEMON STREET is snapped on a sunny day just before Christmas 2011. Viyella have not yet moved to Boscawen Street and balloons are calling attention to some event or other. The dear old Red Lion has been replaced by the Tudor style Co-op but The Royal Hotel is still there, looking clean and with a brightly painted coat of arms over the door. Being winter there are no spectacular flowers in the 'tank traps'. The flower tanks help traffic calming in the road but are not popular with everyone. The modern photograph is taken from the part of the road where once Lemon Bridge stood and joined Lemon Street and Lower Lemon Street. One can no longer lean on the bridge and gaze at the river, as it was covered over in around 1926 and is now called The Piazza.

LOWER LEMON STREET
CONTINUED

ALTHOUGH THE BUILDINGS in Lower Lemon Street thankfully have not changed, there are many subtle differences in these two photos, taken over fifty years apart. In the mid-1950s the Red Lion was still a prominent feature of Truro. Built as the town house of the Foote family in 1671, it had been an inn since 1769 but was knocked down after the runaway lorry hit it in 1967. It is not easy to see, but there is a policeman directing traffic at the junction: obviously at that time vehicles were allowed to drive up towards Lemon Street. The Royal Hotel was named after Prince Albert, who visited alone in 1846; Queen Victoria, who had had a busy schedule, remained on board her yacht at Malpas.

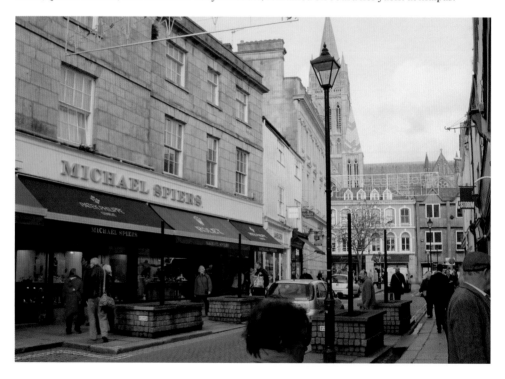

IN THIS MODERN photograph, Michael Spiers' jewellery shop is where once Bullen & Scott, the hardware merchants, had their business. After Bullen & Scott, the elegant dress shop 'Elizabeth' occupied the store for many years. If the tank traps had been *in situ* in July 1967, would they have slowed down the lorry that ran away down Lemon Street and careered across Boscawen Street into the Red Lion? The copper tower of the cathedral is visible above the rooftops and looks very attractive with its green colouring – though when it was built, residents imagined that it would stay copper-coloured and shiny!

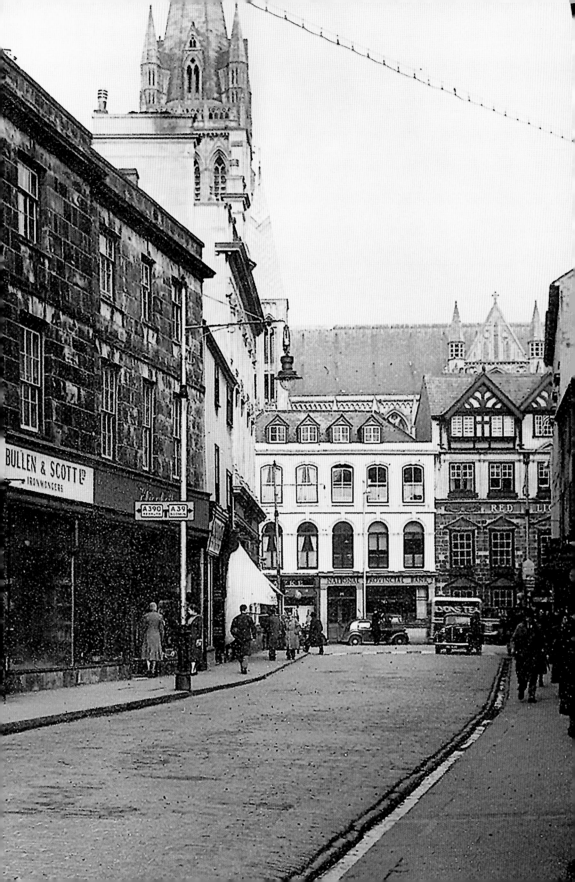

ST NICHOLAS STREET

THE OLD POSTCARD of 1897 is entitled 'Victoria Place', but although the photographer was standing in Victoria Place it is actually a view looking up St Nicholas Street to Boscawen Street. Amos Jennings's grocery store is on the left, later to become WHSmith after that store moved from London House. Edwin Broad's department store is on the right, with Radmore's dining rooms opposite. This postcard was sent to a little girl in the infirmary by her mother. St Nicholas Street gets its name from the guild of St Nicholas, and is one of the oldest streets in Truro. It was in St Nicholas Street in 1958 that workmen digging up the road found the head of the old cross, identified

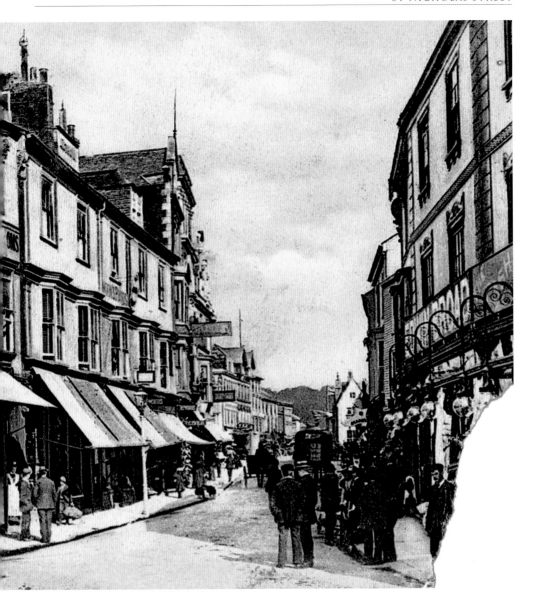

by Mr Douch, the curator of the museum at that time, as part of the original cross that stood in High Cross for many years.

ST NICHOLAS STREET is still a busy street and over the years has housed such shops as Dingles and Criddle and Smith. It is interesting to know that the granite shaft of the old cross is still under the road: the workmen in 1958 did not realise what it was, and left it there as a large piece of road fill. Looking from Victoria Square, we can see a bench outside Rowe's the bakers, and come lunchtime it is usually taken by people enjoying a break from their shopping and eating a pasty in the traditional way... out of the paper bag!

VICTORIA SQUARE

ALTHOUGH THE OLDER picture, taken in around 1905, is entitled 'St Nicholas Street and Square', the place where the photographer stood to take his photograph is Victoria Square. This was one of the places where the horse buses from the country waited until it was time to take their passengers home again. The 'iron duke' gentlemen's toilet would possibly have been a welcome sight for the gentlemen passengers as they alighted from the coach. Perhaps the ladies made a trip to the Victoria Hotel? This area is the site of the old West Bridge and has been flooded many times in the past. It is also where the friary complex was built when Dominican monks came to Truro.

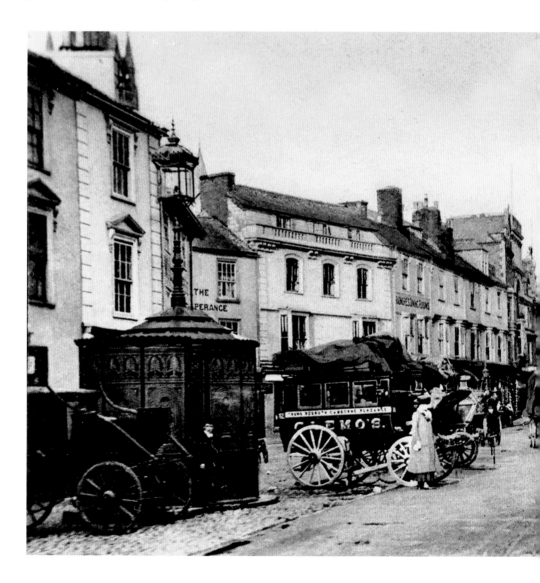

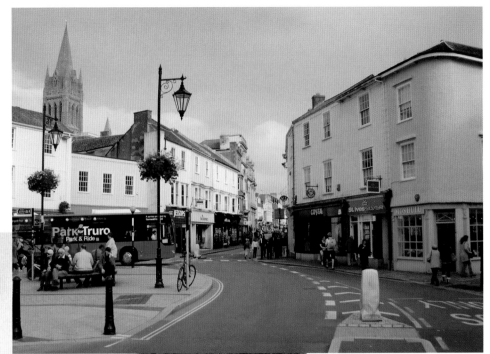

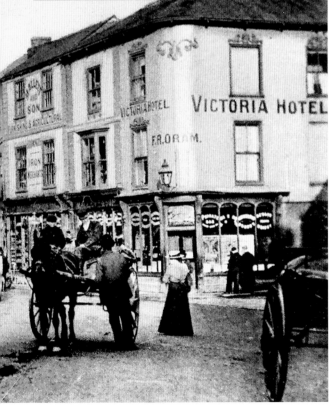

ALL THE SHOPS have changed in the new view. The Victoria Hotel has gone, to be replaced, at the moment, by a shoe shop. The old 'iron duke' toilet was removed in the 1950s, which much improved the area! For many years there was a short-term car park in Victoria Square: if you were lucky and found a space, twenty minutes could give you time to pop into the baker's or to collect a parcel from Argos. Today the car parking is gone and the area is a designated bus stop, with regular appearances by the Park & Ride bus, amongst others. The Park & Ride scheme has meant much less congestion and pollution in the town and is very well used.

BOSCAWEN STREET
CONTINUED

IT IS EASY to imagine how Boscawen Street would have looked in the past. Middle Row was built in the mid-1300s and contained the old Market House (which would have been at what is now the King Street end of the row). This row of buildings was pulled down in around 1806, and the Daniell tablet, dated 1615, was moved from the Market House to be re-erected in the entrance to the City Hall. The carving on the stone states, 'Who seks to find eternal treasure must use no guile in waight or measure', and is signed 'Ienken Daniell, Maior'. In other words, no cheating: only fair trading will be tolerated.

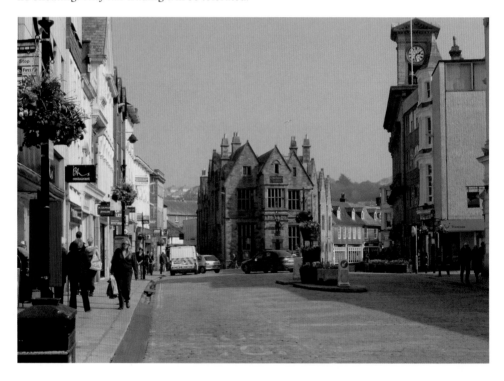

BOSCAWEN STREET TODAY is just as busy as ever and is seen here on an unusually hot Sunday afternoon in March. The horse trough is visible on the island beside the bollard. The two roads on either side of the Coinage Hall, Duke Street on the left and Prince's Street on the right, give an idea of the width of Market Street and Fore Street in the past. The current clock is housed in a tower of the same style as the one that went up in flames but now has a white face. The original Coinage Hall was replaced by the present building and now contains a tea shop, antiques shop and a pizza restaurant.

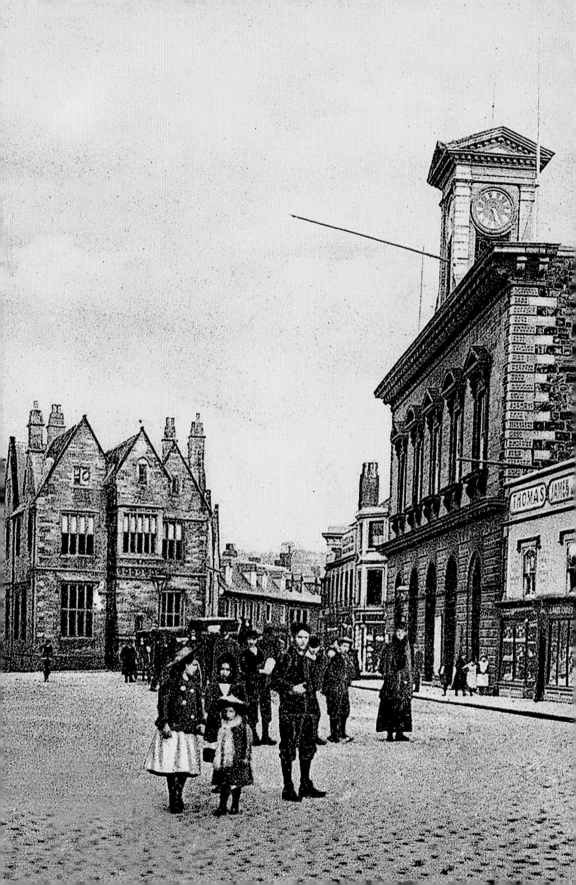

DUKE STREET

AS WE CAN glimpse part of the war memorial in the old photograph, we know that it was taken sometime after 1922. On the left is Treleaven's Café, advertising lunch and teas – and also, on a sign just beside the door, Peach Melba! Other tea rooms are advertised on the building behind the

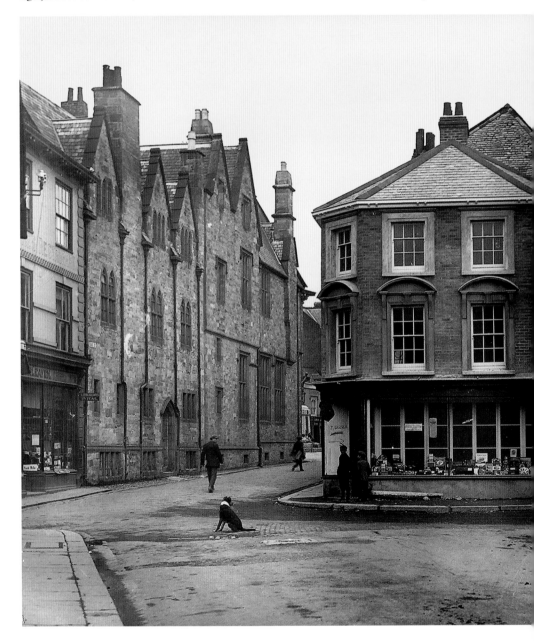

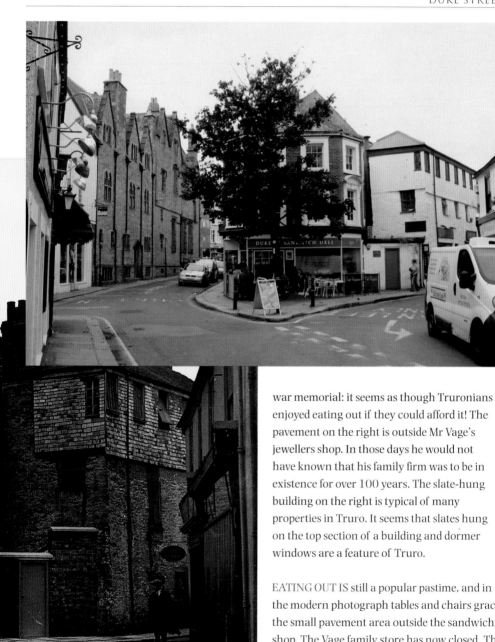

war memorial: it seems as though Truronians enjoyed eating out if they could afford it! The pavement on the right is outside Mr Vage's jewellers shop. In those days he would not have known that his family firm was to be in existence for over 100 years. The slate-hung building on the right is typical of many properties in Truro. It seems that slates hung on the top section of a building and dormer windows are a feature of Truro.

EATING OUT IS still a popular pastime, and in the modern photograph tables and chairs grace the small pavement area outside the sandwich shop. The Vage family store has now closed. The tree is a welcome addition to the square and makes a shady spot for the tables and chairs of the sandwich deli. It seems to be a cat and not a dog that rules the roost at the end of Duke Street these days, but she is streetwise and did not stay for the photo.

QUAY STREET

WE ARE IN Quay Street in this old view, taken in the 1920s. Treleaven's Café is on the left. Treleaven's was also a bakery and the company had a department that catered for various functions around the town. The building was demolished in the 1960s and later replaced with a modern structure. John Langdon's cycle shop was in St Mary's Street for many years and was well frequented by youngsters needing parts for their bicycles in the days when cars on the roads

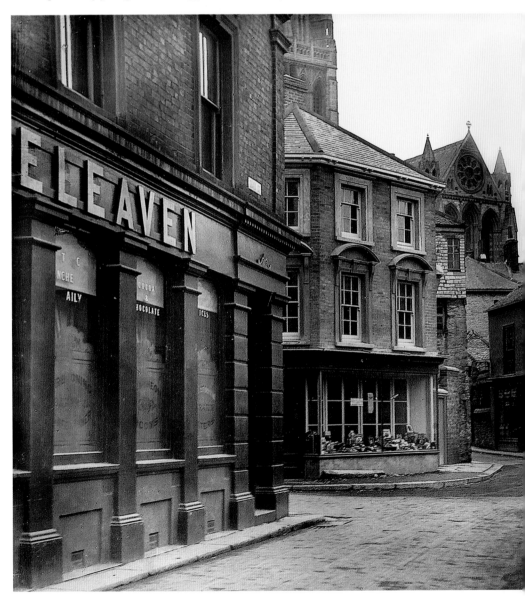

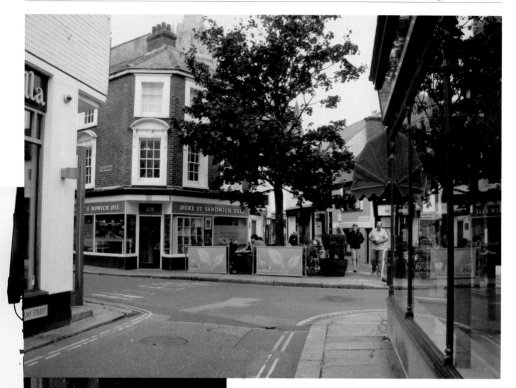

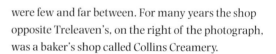

were few and far between. For many years the shop opposite Treleaven's, on the right of the photograph, was a baker's shop called Collins Creamery.

COLLINS CREAMERY, A familiar feature of the 1950s and '60s, is now Warrens the bakers, and has been for many years. The tree adds character to the outside café and the brightly painted properties at the end of St Mary's Street give a cheerful aspect. As one would expect, in the past Quay Street led down to the quays that were dotted all along the riverside. The most famous business carried on there for many years was the cooperage owned by the Davey family. W.W. Davey was not the only cooperage in Quay Street: there was also Frederick J. Hawke and Neale's. Farther down the street, an exciting discovery was made in 1867 when the Public Rooms were being built. The old road, 6ft below the road level of today, was found and discovered to be made of 'sea pebbles'. Today it is tarmacked, as is usual.

TRAFALGAR

TRAFALGAR GARAGE WAS opposite the police station
and sold Commer and Sunbeam vehicles and Shell petrol.
Truro does not have many buildings from the 1930s,
with its distinctive style of architecture, and it seems that
Trafalgar Garage was one of the casualties. Even though
it was only a garage it had style, and could have graced
any television drama set in the 1930s. On the right of
the photograph would have been a public house, the Lord
Nelson, which was in front of the police station. Opposite
the police station, at the top of Malpas Road, was the
Admiral Boscawen. Presumably both public houses had
well-behaved customers, as this would not have been the
place to cause a rumpus!

TODAY THERE IS not so much character in the area
of Trafalgar. With the two public houses demolished
and the garage gone, there has been room for a
road-widening project. The roundabout is quite large by
Truro's standards and leads to Tregolls Road,
St Clement's Hill, Malpas Road, Morlaix Avenue or

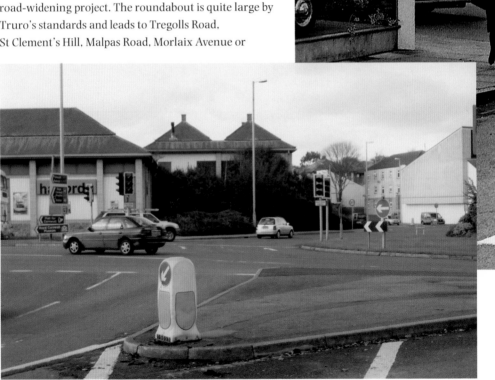

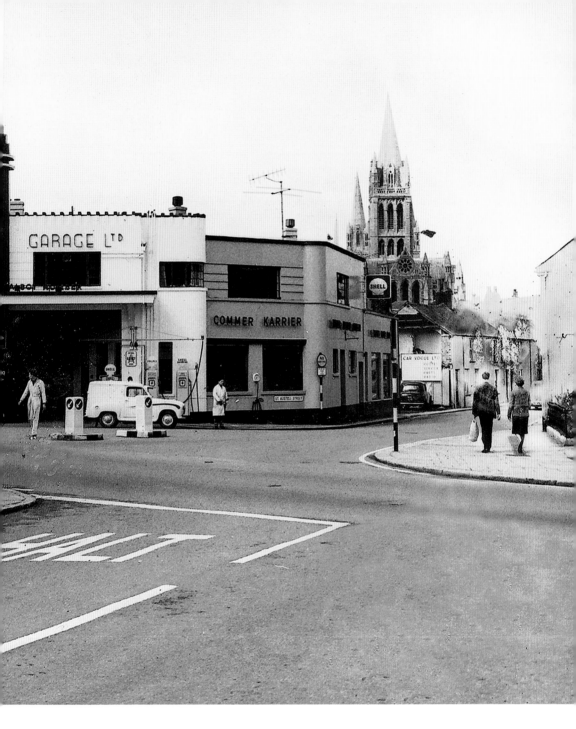

St Austell Street. St Austell Street used to be a fairly narrow road lined with cottages but that
has changed. For many years the Post Office's sorting office was on the garage site, but when the
Post Office staff moved out, and their building was demolished, Halfords took over. The 'new'
(1972-3) Roman Catholic church is on the other side of the road, close to the area where the
Lord Nelson had been.

TOP OF MALPAS ROAD

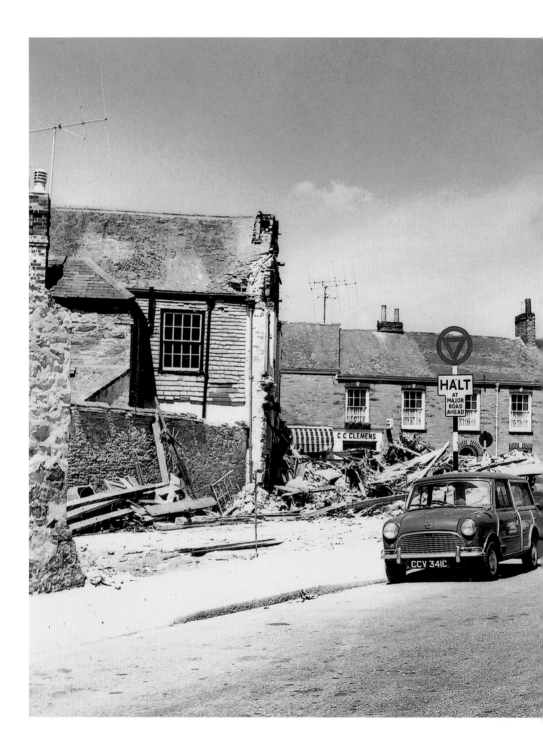

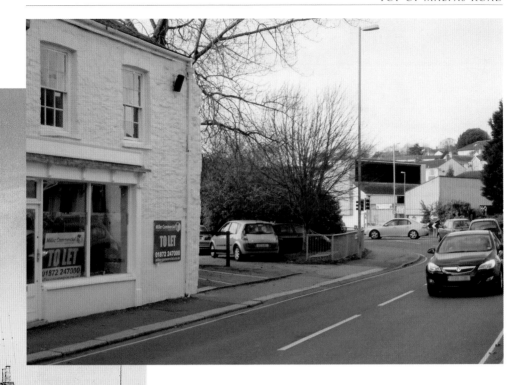

PART OF THE changes in the Trafalgar area included the top of Malpas Road. The Admiral Boscawen was knocked down in 1966, opening up a view of some of the cottages leading to Boscawen Bridge. Many of these cottages contained shops such as C.C. Clemens', seen here, and farther along the same road was a very good and well-used fish and chip shop. The fish and chip shop had been owned by the George family at one time and also by the Williams family (who also owned a fish and chip shop in New Bridge Street that was just as popular). The shell garage at Trafalgar just creeps into the right side of the photograph, and a typical slate-hung cottage looks very rickety on the left.

THE MODERN PHOTOGRAPH was taken from slightly to the left of the old one and captures a part of the roundabout with the Roman Catholic church of Our Lady of the Portal and St Piran, built in 1972. Today the road to Malpas that was once mostly used by pedestrians is busy with cars and the car park of Radio Cornwall is usually packed. One of the most popular games for children used to be to climb on to the timber humps – once part of the timber yards but now barely noticeable – as they went down to Malpas Park. An empty shop stands at the top of the road, but farther down there has been much improvement to the old warehouses.

RIVER STREET

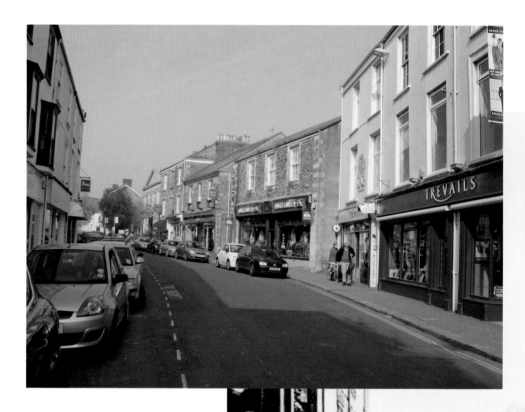

THE PHOTOGRAPH ON the right, taken in around 1900, shows a much quieter River Street than today. One of the towers of the Congregational Church can be seen on the right but no trace of the building remains today. The arched entry into The Leats, once at the rear of the chapel, is the only sign that a religious building had been there. The pointed roof of the museum can just be seen through the trees. The road was developed in the 1840s to provide a wider road into the town centre from the new houses around Castle Street, as tradesmen complained that Kenwyn Street was very narrow for their vehicles.

RIVER STREET TODAY is very busy and usually has cars parked down its length. It is on the bus route for the Park & Ride as well as many other bus routes and is often clogged up. The museum is visible at the end of the road. The building that is next door to it was the former Baptist Chapel and is another very elegant building but, being set back from the road, it cannot be seen in this view. The architect of both buildings was Philip Sambell, a deaf mute who left a legacy of several beautiful buildings in Truro. The River Kenwyn flows under this street, but it has been known to flow on top of it in heavy rain! Fortunately, the flood-defence scheme seems to have kept this in check in recent years.

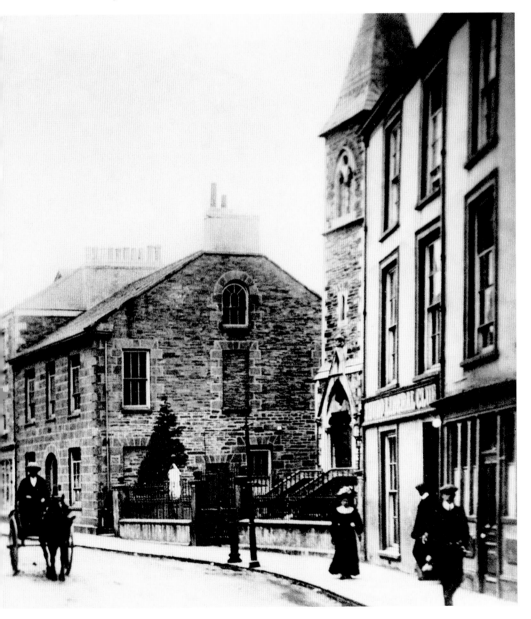

MUNICIPAL BUILDING

THE MUNICIPAL BUILDING in Boscawen Street was designed by the architect Christopher Eales and built between 1846 and 1847. Seen here in 1904, we also have a good view of the pump, the fountain and the horse trough. They have all since been moved. In November 1914

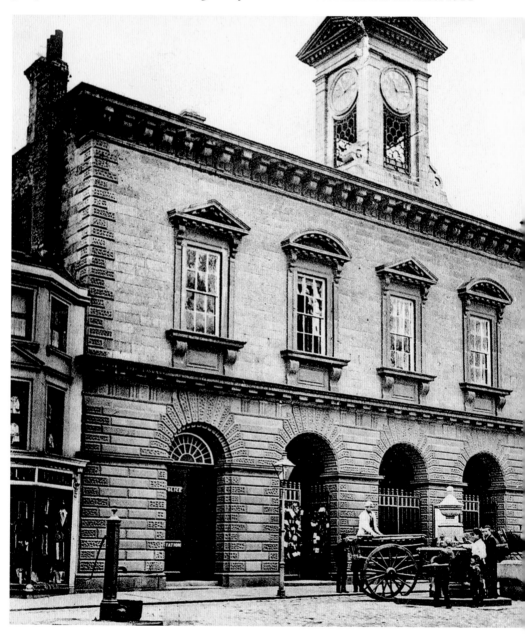

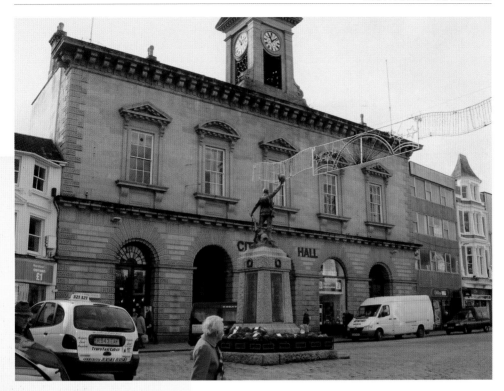

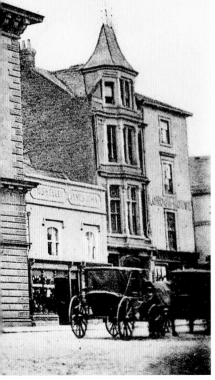

a fire broke out in the municipal buildings and the clock tower crashed down into the Council Chamber below. An anonymous donor paid for a replacement and an identical structure was built, but the new clock face was white rather than the original black. For many years the Regent cinema was housed in this building and there was also room for dances, ice-skating, flea markets and other entertainments in the City Hall. The City Hall was a favourite place for schools to hold their Speech Day concerts and prize-giving events.

TODAY THE BUILDING is home to the city council's offices on the first floor, which include the Council Chamber, committee room and Mayor's Parlour. Across the hall is the Town Hall, which was once used as the courtroom. The Terrace Café uses the part of the front of the building under the arch on the left of the photograph, and the new Tourist Information Centre is under the arch, second from right, while the rear of the building is the 'Hall For Cornwall', a very popular theatre with a programme of shows that cater for all ages and tastes.

ST MARY'S STREET

IN 1259 BISHOP Bronscombe came down from Exeter and consecrated the chapel of St Mary, which later became the parish church. When the church was pulled down, the south aisle was incorporated into the cathedral. Narrow St Mary's Street runs alongside it. The Walpamur van is parked outside what was, in the 1960s, the Walpamur shop, selling decorating materials. The building used by this company was part of the old grammar school, founded in 1549 by Walter Borlase. Many pupils who later became famous studied there: Richard Lander, who followed the course of the River Niger; Humphry Davy, who invented the miner's safety lamp and discovered 'laughing gas'; Henry Martyn, a missionary; Samuel Foote, the actor; Edward Pellew, involved in the abolition of slavery; and Sir Goldsworthy Gurney, whose steam carriages made standardised time throughout the country a necessity.

ST MARY'S STREET is known as the draughtiest street in town but is also one with plenty of character. The south aisle of the cathedral came be seen clearly: this is the part of the old St Mary's church that was incorporated into the new building in 1880. The old wooden setts that were laid down to prevent the noise of carriage wheels disturbing services can still be seen occasionally if the tarmac wears away. The Royal British Legion has occupied the vacant plot since the 1960s. One big change is the disappearance of Vage's jewellers; a restaurant now occupies the premises. What would William A. Vage have made of that? He would not even leave his shop without his hat, even to give chase to the man who perpetrated a smash-and-grab raid on his shop.

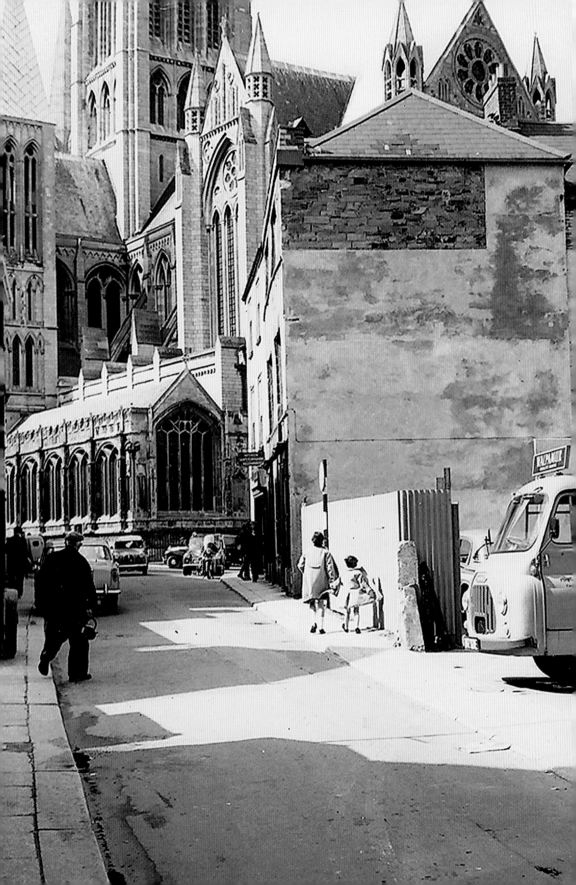

JUNCTION OF CHARLES STREET AND CALENICK STREET

THIS VIEW OF the area at the bottom of Infirmary Hill has changed several times in recent years. The prettiest building is St Andrew's Chapel. It formed part of St John's church, which was close by in Lemon Street. Part of Calenick Street is visible, much changed from the way it was in earlier years. In the 1930s it was considered to be a fairly rough part of town, with public houses and the doss house not helping its reputation. It was not all bad, however: we know a child could safely deliver a Christmas dinner to the doss house without coming to any harm. There was also a popular bake house in the street for those people who did not have baking facilities of their own.

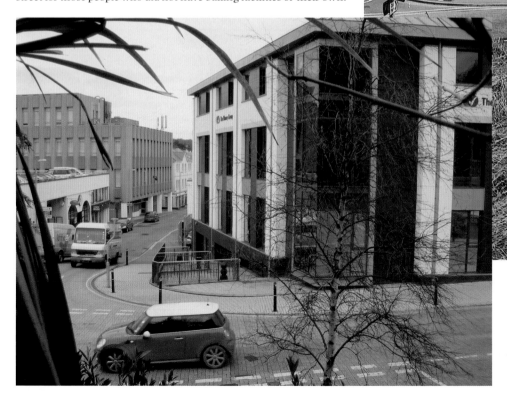

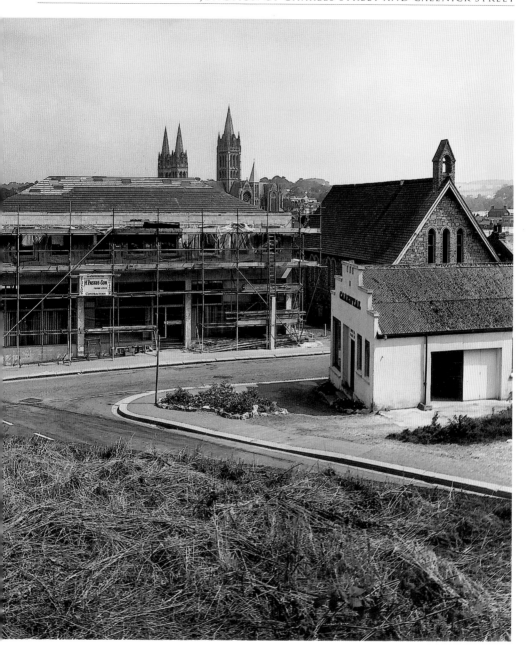

IT WOULD BE impossible to take a photograph today from the same place as the older photograph without falling out of a hedge on a high bank, but the little building on the right, now used by Camera Craft, is still there. These days Calenick Street is a thriving business area and a well-used road that leads to the Moorfield car park. The Moorfield was where the fair set up for business for many of their visits to Truro before moving to the Green in later years. Today the little chapel of St Andrew has gone, and a large office block has taken over in Charles Street.

THE LEATS

THIS 1960s VIEW of The Leats was taken during the time when it was forbidden to do anything other than walk through this narrow road. The park keeper patrolled The Leats area even though this section was the farthest from the park. Even bicycles had to be pushed and not ridden. The channel of the leat can be seen on the left, with granite slabs crossing it at intervals to give access to the houses there. The first crossing led to the big house owned by musicians Mr and Mrs Lightbown. Farther down there was access to The Peoples' Palace, an old-time leisure centre that catered for games such as snooker, skittles and boxing, and was also the venue for more genteel pastimes such as a choir. The old Ebenezer chapel became Cornish's sale rooms and was later knocked down.

HOW THINGS HAVE changed in The Leats! Whereas once it was pedestrians only, today it is a service road for the shops that back on to it and regularly has cars parked there. Kingfishers used to flit up and down to the water, but the water is hidden beneath the road these days. At the end of The Leats is a circular area where cars turn so they can exit the

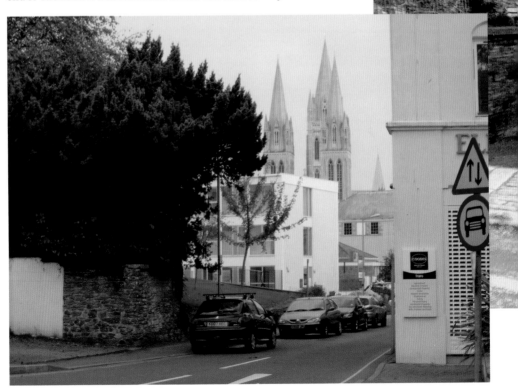

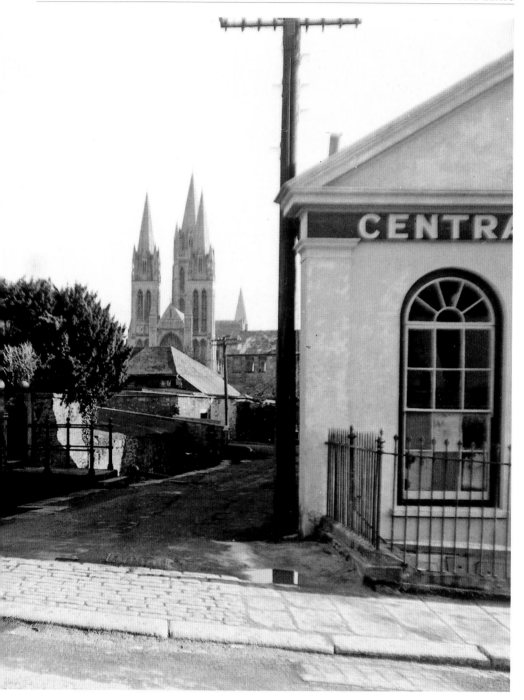

same way they drove in. How many people know that this was the site of one of Truro's cockpits? When the cock fights stopped, the land was taken over and used as a chapel – and the worshippers there were known as the Cockpitarians.

OLD BRIDGE STREET

MANY PROPERTIES THAT were family homes in Truro in the past are business properties today. This is particularly true of the houses in Edward Street and Castle Street, many of them being solicitors' offices close to the court. This 1935 or 1936 photograph was taken in Old Bridge Street. The house is No. 10, the home of the Nicholls family, whose children are outside on the narrow pavement. They are Frances, Pamela, Frank, Pauline and Barbara. Their cousin Jean is the small girl in the gymslip. Their house would have been dominated by the cathedral – and in all probability when the cathedral was first able to ring its bells the occupants of the house would have been deafened, as was most of Truro. Screens were later fitted in the tower to muffle the sound enough to make it pleasant.

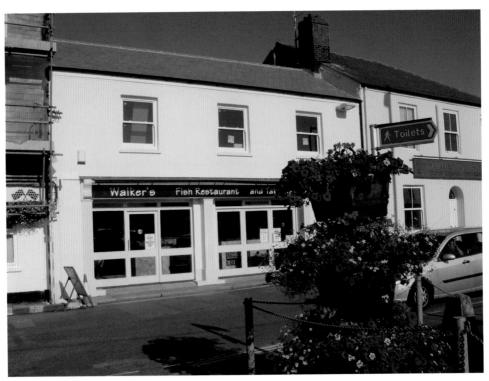

HOW MUCH BRIGHTER and more cheerful that same house looks today! It is now a fish and chip shop, and is easy to access as the short-stay shopper's car park is across the road. At one time this land was a scrap yard. The bridge now called the Old Bridge was originally known as the East Bridge and has also been known as St Clement's Bridge. For many years The Barley Sheaf public house was a popular feature of this street: it was known for its meals, which were excellent, and for its many sports teams. However, that establishment is now closed, and a restaurant has taken over on the premises.

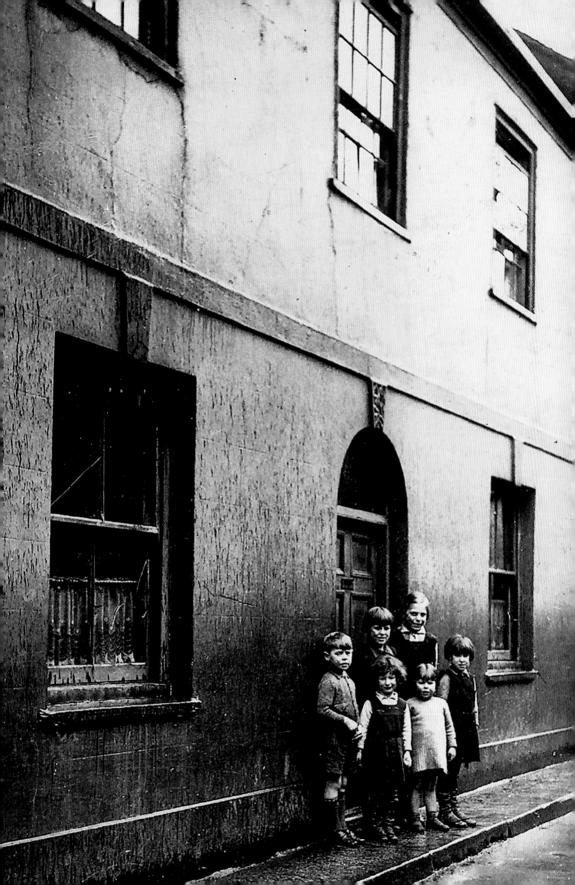

SHOE SHOPS

LENNARDS' SHOE SHOP also had a shoe-repair factory. Shoes from all over Cornwall and Devon were brought here to be repaired, and there was also a contract with English China Clay. The shoes to be repaired had to be collected from the railway station and arrived in large wicker baskets. They had to be ready to be sent back by 4.30 p.m. The staff of the repair department are pictured here in around 1957, and are (from left to right): Jack and Doris Nancarrow; -?-; Derek Boughton; E. Cocks; Bert Lamerton; Tom Matthews; Trevor Cowell; and Nick Carter. Mr Carter later became manager of the shop.

Derek Boughton famously fell off a roof one day. Thinking that he deserved some time off work, he started limping on one leg. Later that day, however, he forgot which leg he had hurt and limped on the other. He ended the day limping on both legs!

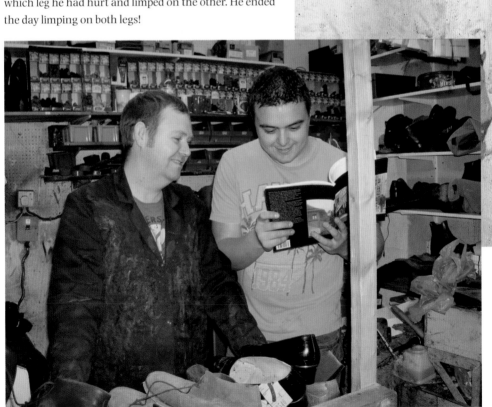

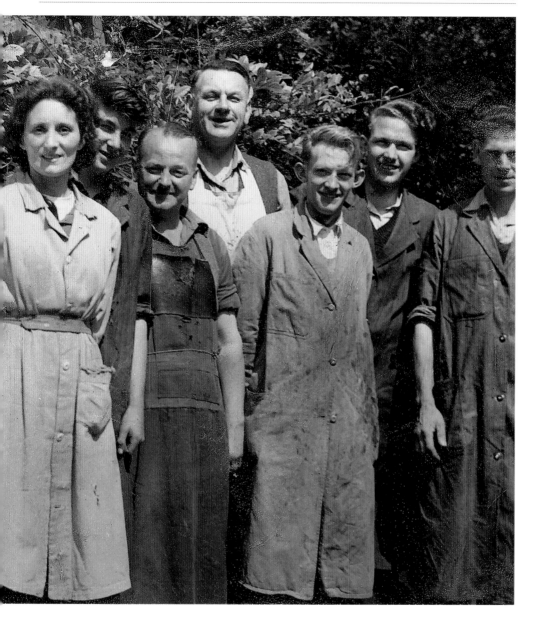

ALTHOUGH WE HAVE more of a throw-away society today, many people still head for the pannier market when shoes need mending. Ricky Kempthorne, who used to work there with Peter Mallett, is still there, along with Ben Kempthorne, and the shop always seems to be busy. The pannier market was once the showrooms of HTP (Hosken, Trevithick and Polkinghorne) when they were chiefly a motor company. During the war this building was used for the repair of components for aircraft, mostly spitfires. These days, small shops jostle for space in the interesting market. The space outside has been smartened up and now has several shops in the Tinners' Market.

REAL BUTCHERS

J. ARNOLD HODGE was known to many people in Truro as a retired master butcher who kept a shop in Frances Street for many years. He was a pork butcher whose famous pork sausages and hog's pudding are still remembered. He was a long-standing member of Truro City Council and, at different times, a member of Carrick Council and the county council. In 1947, however, it was a different story: he was the store man at the Ministry of Food depot in City Road, and as food was rationed he was responsible for loading the correct amount of lamb on to the lorry for RNAS Culdrose at Helston. He is seen here working in a temperature of 22 degrees below freezing – but as this was the time of the '1947 big freeze', he was never sure if he would have been any warmer outside!

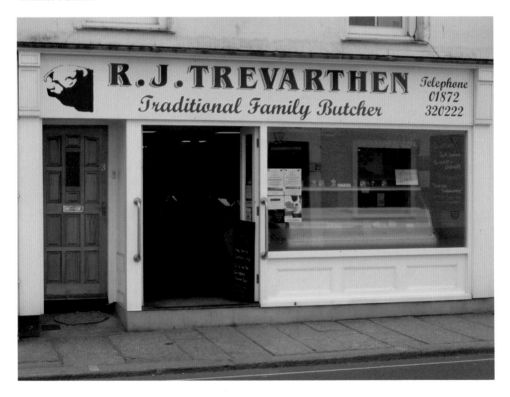

FOR MANY YEARS we have been used to buying meat in a little plastic-wrapped tray from a supermarket, but now real butcher's shops are appearing again. Trevarthen's is in Frances Street, just down the road from Mr Hodge's former premises. It is very popular and has been there for several years now. There is another branch in Perranporth. At one time there was another butcher's shop in Frances Street, one of the two branches of Eastmans in Truro. The other shop was in King Street. A tall thin gentleman called Percy was one of the assistants in the Frances Street shop and was known to hand out little tasters of corned beef to the children.

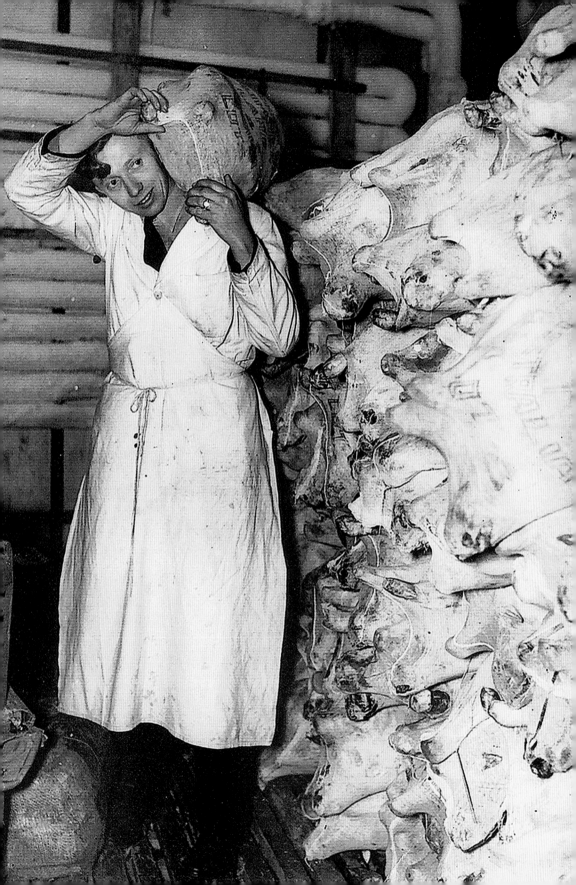

VIEW FROM POLTISCO

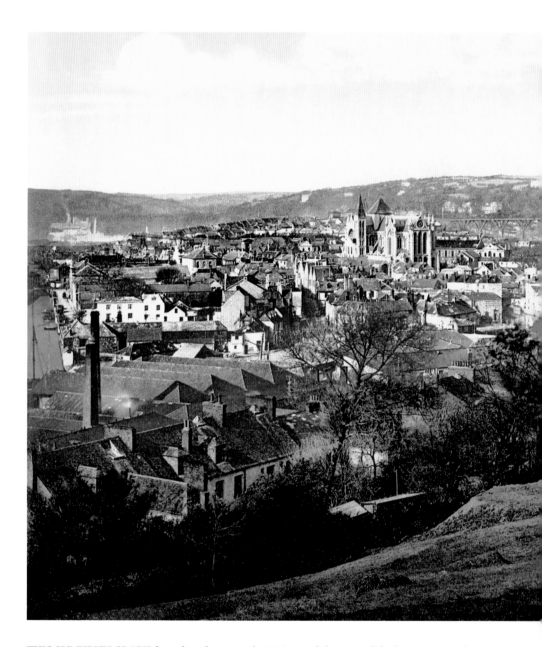

THIS OLD PHOTOGRAPH dates from between the 1890s and the turn of the last century. The building of the cathedral was started in 1880, and here we see it with only the clock tower completed. The two western towers were not completed until 1911. Brunel's wooden viaduct is still in use, and on the left of the picture is Green House. Although the buildings on the bottom

left of the photograph have gone, the chimney has been preserved and now stands alone in a car park in Malpas Road. With a magnifying glass it is possible to see the town clock with the black face in the old tower that was burnt down.

TODAY THINGS HAVE changed dramatically: although the new view was taken as close as possible to the old one, many new buildings and trees have made it difficult to match. Of course, the cathedral now has all three spires (although at the moment there is much fundraising going on as the soft sandstone is weathering badly, and there is much-needed restoration to be done). On a hot hazy day in March it was not easy to get a very clear photograph, but towards the top right of the view it is nevertheless just possible to make out the arches of the stone structure that replaced the wooden viaduct.

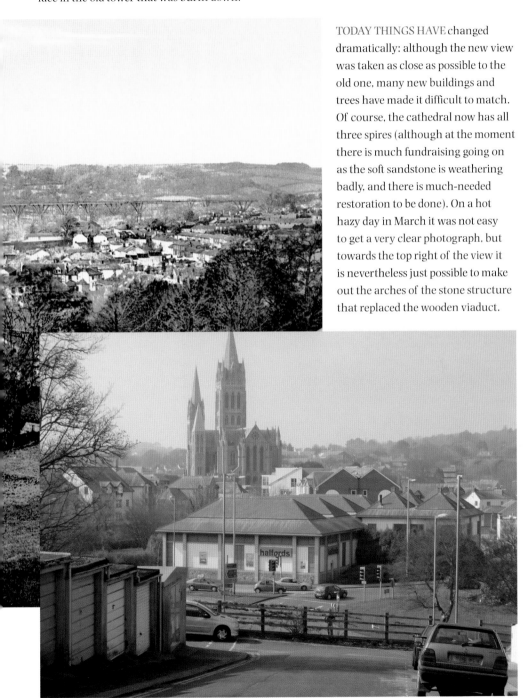

IN THE ARMY

BEFORE NATIONAL SERVICE was abolished, all the local boys wondered where they would have to serve and which regiment they would join. John Colston (centre) and his comrades Billy Penfold (left) and Stuart Davey (right) were destined for the Duke of Cornwall's Light Infantry. After ten weeks of training at Bodmin Barracks, they passed out on 19 October 1956. General Sir George Erskine, the commander in chief of the South East Command, was the inspecting officer. However, as the Durham Light Infantry were approximately forty men below strength, John was in the group chosen to join them for another six weeks of advanced training. This was at the time of the Suez crisis.

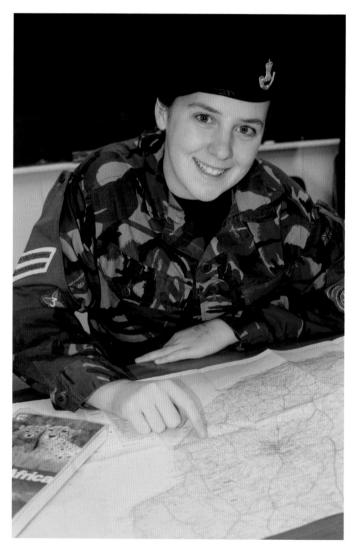

CADET SERGEANT ASHLEY Palmer from the Truro Platoon will be participating in the Kwazulu-Natal Northern Venturer Expedition in July 2012. The only cadet from Cornwall, she is one of fifty-seven cadets flying out to the Kwazulu-Natal province. After a short period of acclimatisation, she will be undertaking an unsupported traverse of the Drakensberg escarpment which will take in the highest peak in Southern Africa, Thabana Ntlenyana. Before being selected she had to undergo three weeks of gruelling training, and before tackling the Drakensberg she will be trekking and living in the bush. The team of cadets will then spend five days making improvements to a Zulu village school.

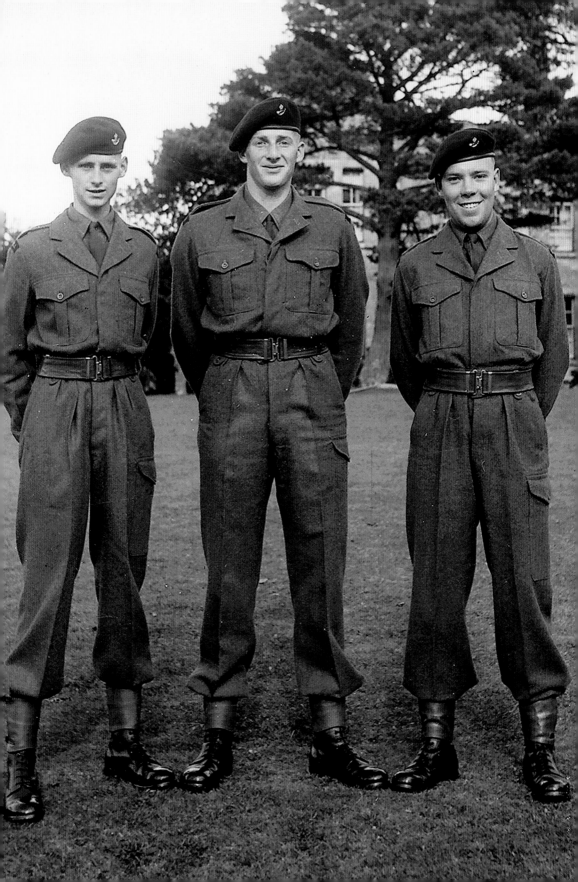

THE PIAZZA

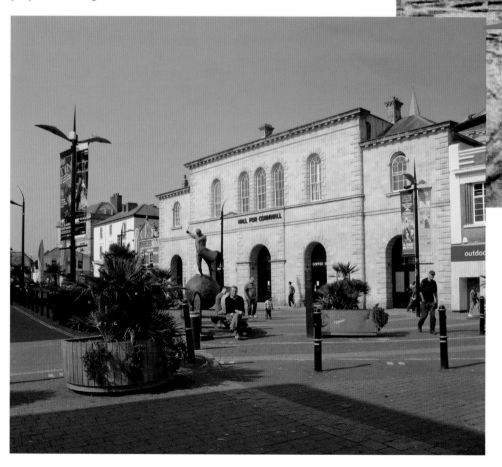

WORK STARTED ON covering over the River Kenwyn between Lemon Quay and Back Quay in 1926, but before that time boats used to come right up the river to unload. The old photograph shows the Peerless lorry driven by Mr Henry May, known as Yank, who worked for Western Counties Agricultural Valuers. The boat was carrying grain which was loaded into the lorry. Although this old picture is not very clear, it is rare to find anything showing a ship at Back Quay. The back of the municipal building can be seen, but the building next to it has gone and the 1930s façade, well known for many years as F.W Woolworth, would be more familiar to us today.

ON A SUNNY afternoon the new statue of the drummer towers over the people wandering across The Piazza. In winter this is where one of the

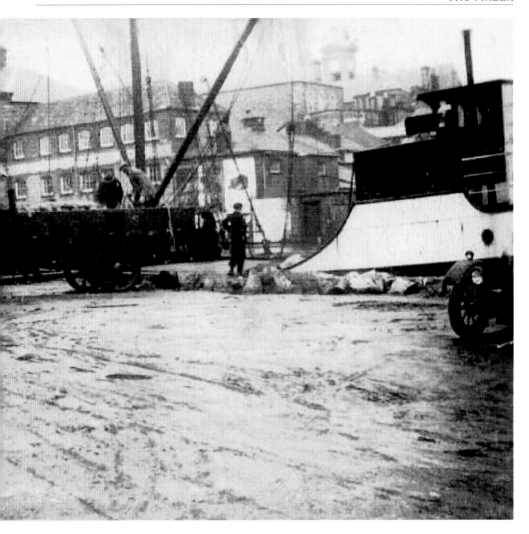

Christmas trees is erected: the other is outside the cathedral. There are often farmers' markets
and craft stalls here and this space is also used to hold the Fat Stock Show every December. The
buildings show a mixture of styles: the 1930s Cotswold shop, which used to be Woolworths; the
Italianate back of the municipal buildings, which now houses the Hall for Cornwall; and the
quaint style of the building known for many years as The Market Inn. There used to be a view
of the town clock from here, but the fly tower of the Hall for Cornwall makes it impossible to see
these days.

DREADNOUGHT
PLAYING FIELDS

THIS VIEW OF the Dreadnought Playing Fields (named after Admiral Boscawen, whose nickname was 'Old Dreadnought') was taken in the early 1960s, and shows two playing fields –

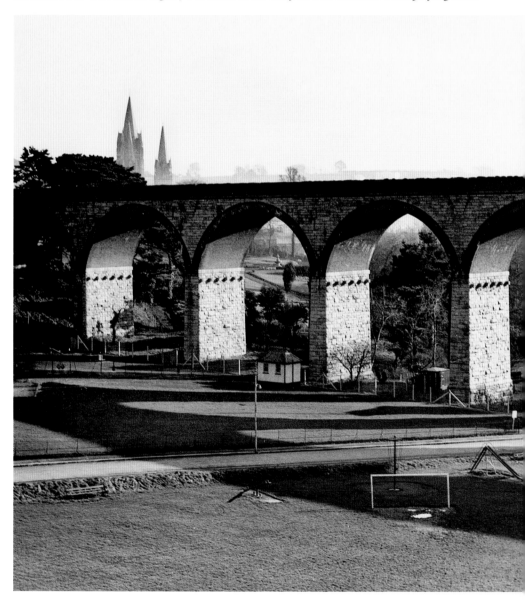

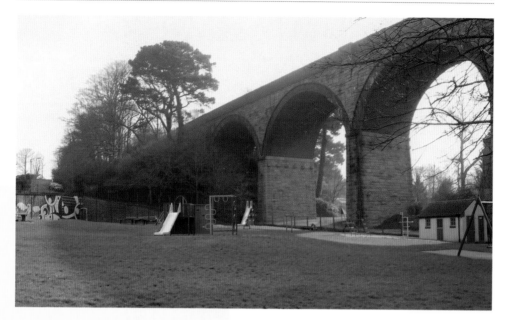

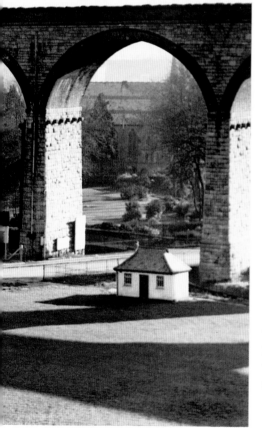

and very little else. The higher field was known as the girls' area and the lower one was for the boys. The little buildings on them were their respective toilets. Through the arch of the viaduct on the right can be seen the Waterfall Gardens and through the arch above the girls' toilet there is a glimpse of some of Victoria Gardens, including the fountain in the middle of the lily pond.

ALTHOUGH THE LOWER field is much the same as before and is suitable for games of football etc, the other field now has an array of interesting play equipment to amuse young children. As well as the climbing frames and slider in this picture, there is a mural on the back wall, and lower down the field there is a huge tube through which to crawl and have adventures. The old toilet block has gone and a new one is in its place. These days it is possible to walk through under the arch of the viaduct to reach the other two parks and The Leats. A good way to reach the town is to walk through The Leats, which is much more attractive than walking along the street.

TRAFALGAR

THE TRAFALGAR AREA has changed over the years: both public houses, the Admiral Boscawen and the Lord Nelson, have gone, and the old police station made way for a new one in 1974. The garage has been demolished and the road widened, and possibly this area would be unrecognisable to someone beamed down from the 1950s! This shot of Trafalgar post office,

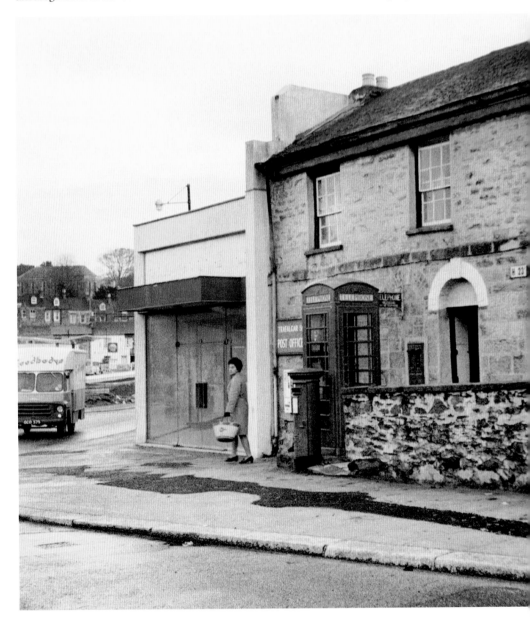

which was where Mr and Mrs Luck
lived with their daughters Christine
and Sandra, shows a building that was
taken down in the late 1960s and the
short-lived showroom of the garage, also
knocked down. It was the place to go to
buy a Commer or a Sunbeam car and the
showroom was quite an attractive building.

AS CAN BE seen in the new photograph,
the cottage next door to the post office has
survived but it is possible that the days of
the 'new' police station are numbered! For
many years the part that looks like a box on
a tower has not been used for the social club:
perhaps too much dancing would cause it to
collapse. A seat has been carefully placed so
that anyone taking a rest can observe all the
traffic that flows through the roundabout,
but the best view is at Christmas when
a tableau is set up on the grass of the
roundabout and illuminated.

NEW BRIDGE

THINGS HAVE SMARTENED up around the River Allen in Truro, and although the old photograph of the 'new' bridge is fascinating, it looks rather down-at-heel compared with today. The opeway from the road (on the right) leads to steps down to the water. In those days the river was used much more than it is today and it would be usual to see boats moored there. Mr Peters, who kept his chickens on Furniss Island, moored his little rowing boat there and went over to see to his chickens every day. The road leading to the bridge (New Bridge Street) was lined with shops including William's fish and chip shop, Mr and Mrs Smith's grocery shop and Halls the butcher's.

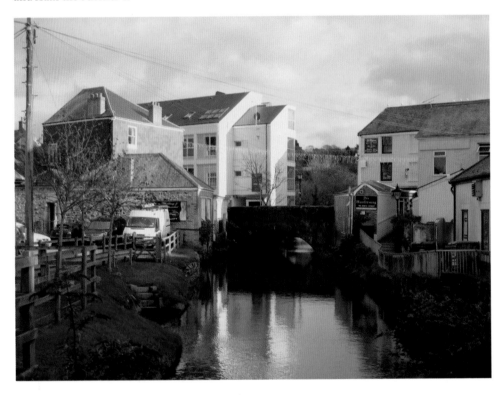

TODAY THE RIVERSIDE Walk runs alongside the bank opposite the shoppers' car park. The walk continues on the other side of the street and runs right down to Garras Wharf by the Tesco car park and then continues down at Malpas. It is interesting to see that the old gas light on the bridge is still of the same style today and adds character to the area. The new bridge was constructed in 1775, and the arch is in contrast to the old bridge just a little way upstream (which is medieval and has a square appearance). Two footbridges have been built in recent years, one either side of the new bridge. The one downstream is a private one that leads to the housing on Enys Quay and the one upstream leads from the car park to St Mary's Street.

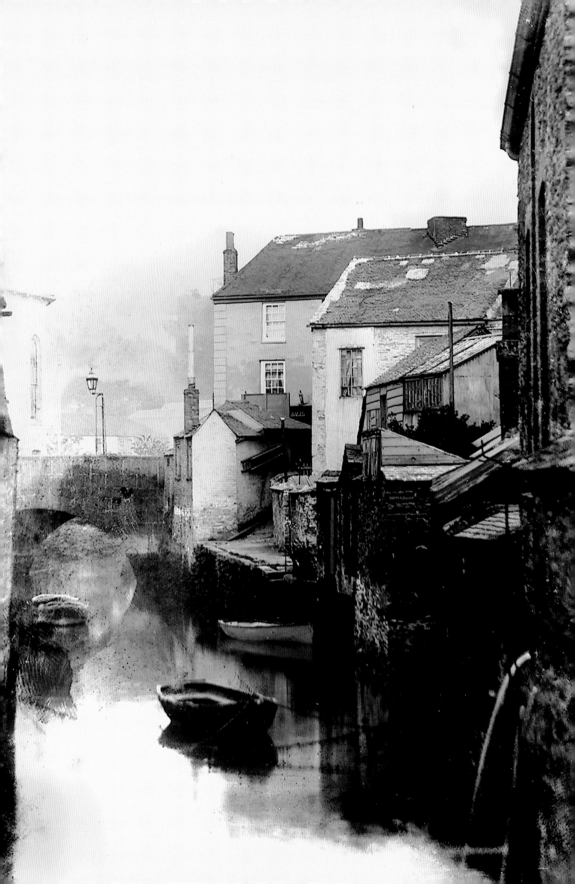

BOSCAWEN BRIDGE

IN THE PHOTOGRAPH on the right, taken just after the Second World War, the area round Boscawen Bridge is a hive of activity. Local people have always enjoyed a trip on the river and two of the boats are Skylarks owned by Peter Newman at Tolverne. The other could possibly be the *Gondolier*. The bridge is the second Boscawen Bridge, built in 1862, the first one having been a rather unsatisfactory wooden structure. The building on the right has been, at different times, Hicks' Garage, Penrose sail-makers and Farm Industries. The Penrose factory was famous for making the largest tent in the world. The green Western National buses had their depot by the bridge at that time and some of them are reversed up to the railings.

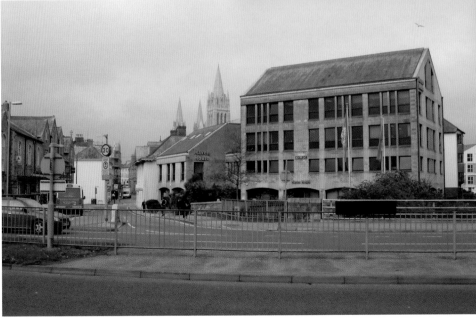

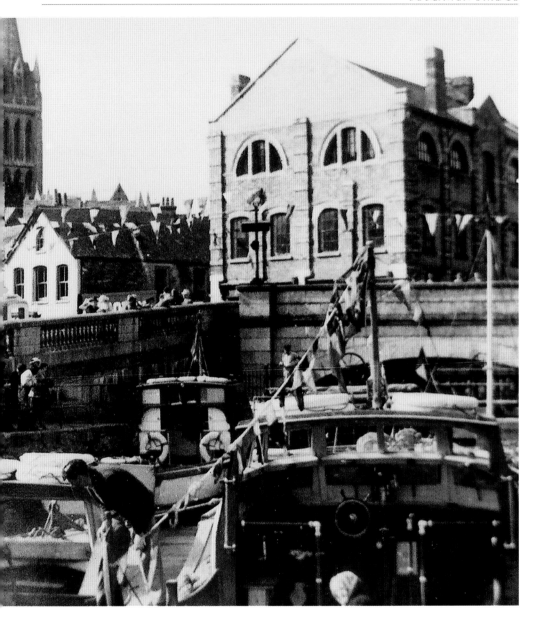

THE MODERN VIEW is taken from Boscawen Bridge. The 1960s bridge carries the traffic over the river on a dual carriageway known as Morlaix Avenue. It is not an attractive structure like the one in the old photograph, but plain and functional. The old Hicks' building has gone and now Haven House, a Truro College establishment, is there beside the lock gates and close to Enys Quay. The Palace Buildings on the left were Truro's last Assembly Rooms, being built to take the place of those in High Cross. In 2011, Truro's most popular flower beds were the ones along the central reservation. They were planted with a variety of wild flowers and were really beautiful.

LEMON QUAY

WHEN THE NEW gas works at Newham came into operation in 1955, the old gas works near Lemon Quay were demolished. This had been the site of a gas works since the early 1800s. It was one of the first in the country. Some of Truro's streets were lit by gas in the 1820s and so no one complained about the construction, even though it was an ugly building and very close to the town centre. Actually Truro had a lucky escape, as one of the plans submitted was a system of

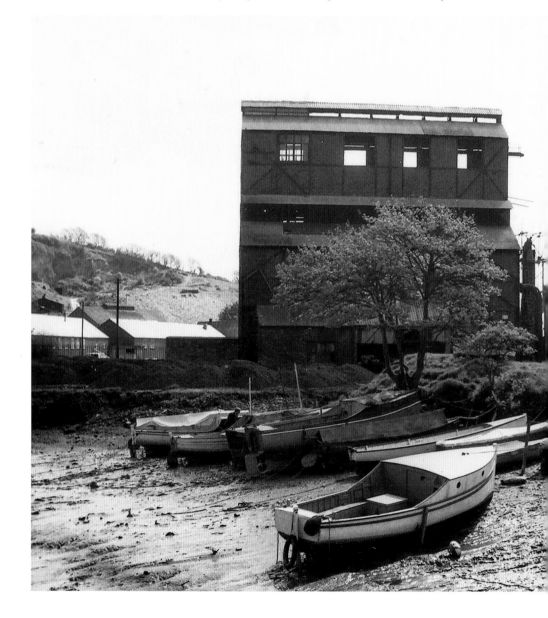

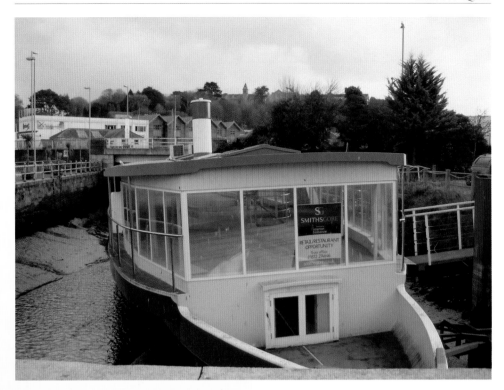

continuous vertical retorts attached to a large building which would have dominated the skyline. The Newham Gas works had a short life, as with the coming of North Sea gas it became obsolete.

WHEN THE RETORT of the gas works was demolished it made a vast difference to the end of Lemon Quay. Many changes have taken place in that part of town over the years, particularly since the 1960s when properties were knocked down to make way for Morlaix Avenue. This gave the opportunity for new developments around the end of Lemon Quay, and today that part of The Piazza often has events such as farmers' markets, craft stalls, sales promotions and a merry-go-round for children. The paddle steamer *Compton Castle* has been a restaurant and a florist's shop and is now waiting for the next stage of its life.

TOWN QUAY

ONE OF THE many quays in Truro where ships could be loaded or unloaded was Town Quay, seen here in around 1911. According to *Kelly's Directory* of 1914, the little shop on the quay was, not surprisingly, known as Town Quay Stores and was the premises of J. Edwards and Sons. They are listed as being 'implement, manure, seed and forage merchants'. The name of the boat

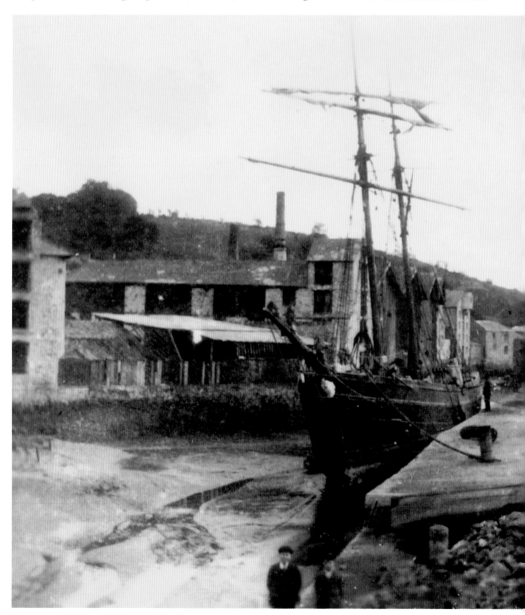

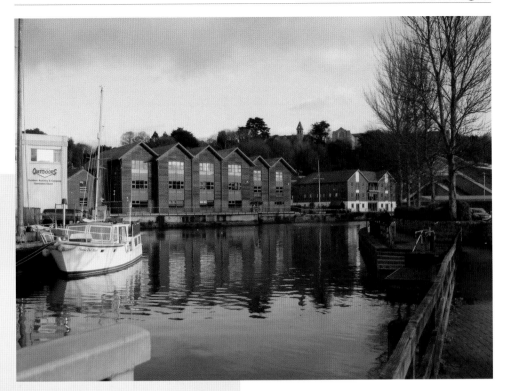

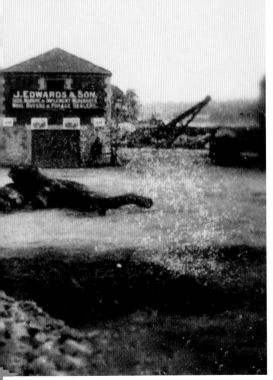

is not known – but, as usual when a camera appeared, two little boys were happy to pose. The old wharf buildings on the other side of the river do not look very prosperous, and the fact that the tide is out – and there is a great deal of mud – gives the impression that times were fairly hard.

HOW DIFFERENT THIS part of the river looks today! This is now Garras Wharf, and part of the riverside walk that skirts the Tesco car park. It is difficult today to know exactly where each quay used to be as so many of them are gone, but this image was taken fairly close to the location of the old picture. New offices and homes have been built on the opposite bank, and the tall warehouse on the right of the 1911 view has been refurbished, but is just out of shot of the newer photograph. Everything looks so much better when the tide is in, especially with a yacht moored up near to the harbourmaster's office.

THE GREEN

THE 1920 PHOTOGRAPH of The Green shows a sailing boat moored much closer to town than it is possible to get today. The car park attendant's hut is outside Green House as The Green was used as a car park at that time. The hut appeared all over town, wherever there was a car park

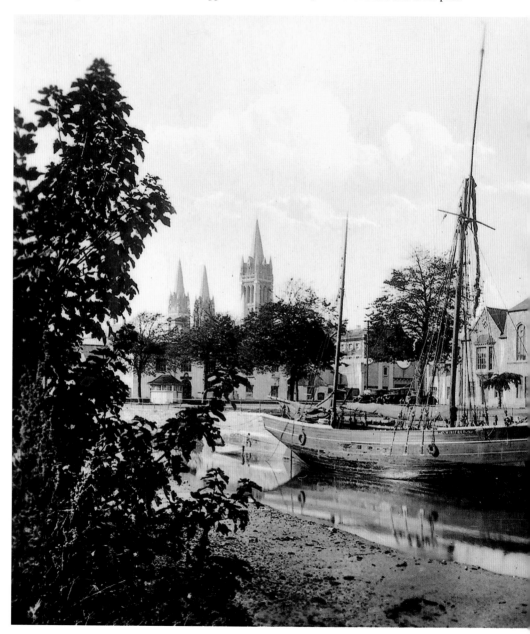

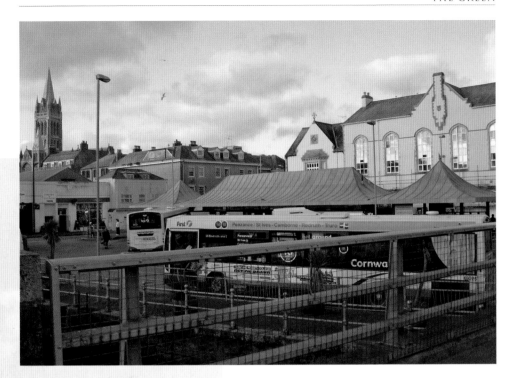

and someone to take the money! Green House was the customs house where harbour dues were paid, and the royal coat of arms can be seen over the door. At the time this photograph was taken the river was navigable up as far as Lemon Bridge so there were often dues to be paid, and boats moored up as close to town as the back of the municipal buildings.

TODAY THE GREEN is the bus station. It is overlooked by the Palace Buildings, which were built to replace the old Assembly Rooms in High Cross. Bishop Philpotts Library is the white part at the end of the building. The books that were there are now at Dioscesan House, together with a fine stained glass window that was removed. Road widening in Green Street meant the loss of the site of the Fighting Cocks inn, birthplace of Richard and John Lander, but at least there is room to get a bus down the road! Usually the modern pictures have more trees in them than the older views, but on this occasion the trees have gone – all except for a few potted palm trees.

THE RIVER

WHEN ALL THE quays and wharfs were in regular use for trade the river was a very busy place, and much of this trade was possible because of the dredger keeping the channel clear. This enabled the larger ships such as the *Emma Louise* of Barnstaple to come right up into town. Unfortunately, the dredger dumped the mud and silt back at the mouth of the river so that, in due course, it had to be moved again. The warehouses in the background face on to Malpas Road and have belonged to different companies over the years: Western Counties Agricultural Valuers, Cornwall Farmers, Farm Industries and Trounson's, for example.

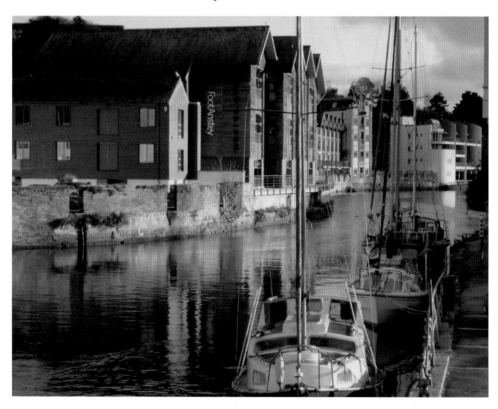

THE MODERN PHOTOGRAPH shows the new and renovated buildings on the bank, but with the tide in we cannot see that, without the dredger, there is once more plenty of mud! At one time Joseph Henry Williams offered the city council a farthing a ton for their mud as he had a project in mind. They demanded a halfpenny a ton instead, and the deal collapsed. One of the wharfs was called Victoria Wharf, named after Victoria Square. It was where a steam lorry belonging to Dixon's was parked every night. Dixon's were wholesale grocers and jam manufacturers and the lorry was parked on the ground floor. The room above had a hole in the floor, and another in the ceiling, so the smoke from the lorry's chimney could escape!

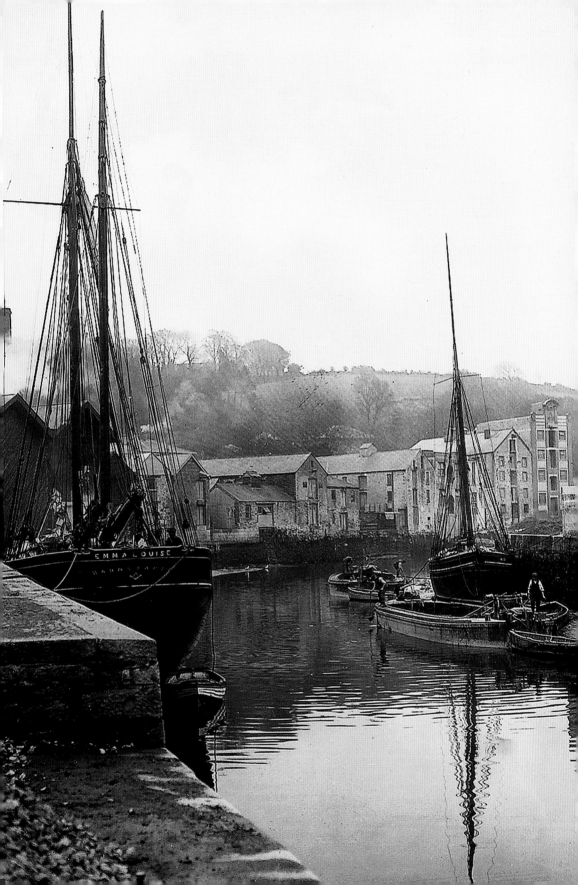

ENYS QUAY

SAMUEL ENYS BOUGHT the manor of Truro and Kenwyn in around 1706 after he inherited the wealth of two men. His grandfather of the same name, a merchant of Penryn, left him a fortune, as did his Truro merchant grandfather, Henry Gregor. When he bought a house befitting his new station in life (known as the old Mansion House), it came complete with its own quay at the back of the property. Long after Enys's time the quay was still used to carry on an assortment of businesses, and even as late as 1960 we can see the premises of W.V. Whitford. He was a picture framer and cabinet maker. There was also a car salesroom on the quay.

TODAY ONLY ONE old building remains on the quay and is converted into a comfortable home. One of the footbridges crossing the River Allen is on the left of the picture, a private bridge for the use of the people living in the flats on the quay. The modern photograph is taken from the part of the riverside walk that runs through Furniss Island. The 'island' is now a park, with a flowerbed of yellow roses in the Burma Star memorial garden, but many people remember when it really was an island and home to Mr Peters' chickens. It is named after the Furniss biscuit company whose factory was where the Sunley Orford Flats are now.

RAILWAY STATION

ALTHOUGH THE RAILWAY station is more or less unchanged, there are several little things that show we have a different way of life today. The lovely old gas lamp on the platform has been replaced by an electric one and the water hydrants have disappeared. Two down trains in the station together would be unheard of today, as the line on the left is the up line. On the far left can be seen yet another train, probably going up the line, with two more trains visible beyond that. In those days the station was painted in the GWR colours of brown and cream.

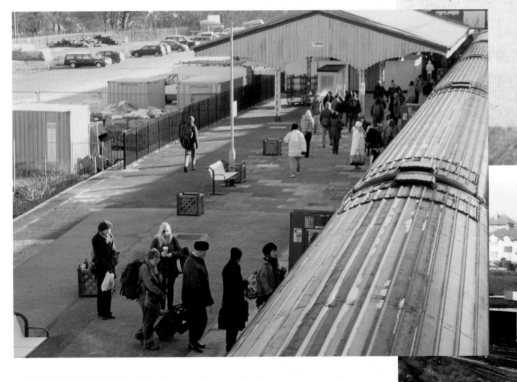

TODAY THE PENZANCE to Paddington train collects passengers early on a bright but cold morning. The photograph was taken from the Black Bridge. The new railings shut those without tickets out of the platform area as automated turnstiles have been installed in the booking office and at the side of the platform. No doubt when the older photograph was current, a platform ticket could have been purchased for a penny or two. These days the brown and cream of the Great Western railway have gone and the station is painted grey and blue. Truro is rather unusual in having two Victorian footbridges to enable passengers to cross the lines.

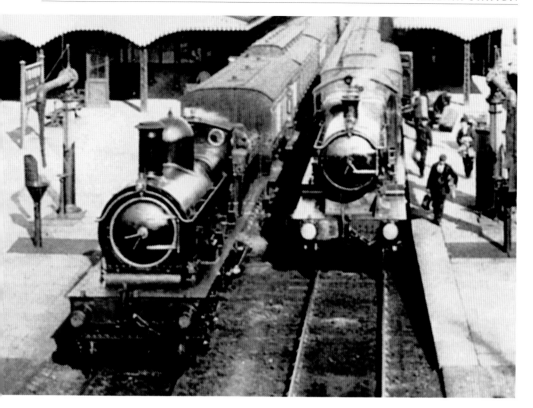

THE TAXI RANK

ANOTHER FORM OF transport that is still much used today is the taxi. Only one taxi is waiting in the rank, which has been between the war memorial and the Coinage Hall for many years. In the past the horse-drawn ones lined up through the middle of town waiting for trade. In this view from the 1960s, several old businesses can be seen. Canon and Collins, the chemist with the attractive door, has gone but the door is still a feature of the street. Jays, the furniture store, and Wymans, the stationers and booksellers, line the street near the famous Red Lion, which was full of character before its demise in 1967.

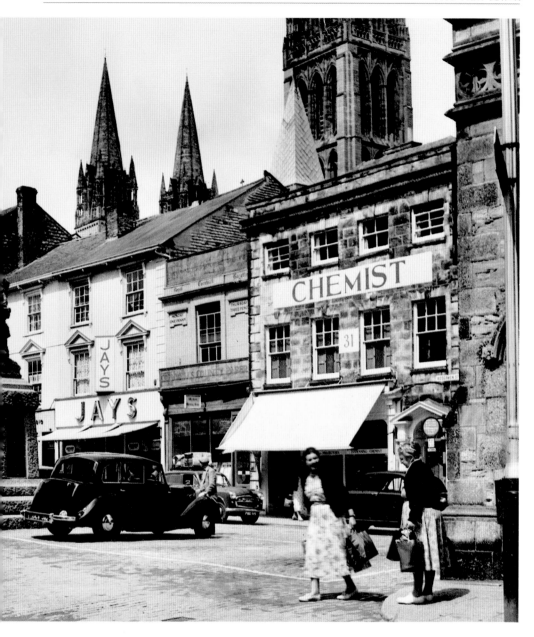

THESE DAYS AN assortment of vehicles park in the taxi rank waiting for business. Any type of car seems to be available, from a luxury model to a people carrier. This area was between the end of Middle Row and the old Coinage Hall in the past and was once the site of the lock-up. Trouble makers could then easily be transferred to the court room in the Town Hall 'under the clock'. The point where the old traditional granite setts end and the modern road surface begins is very noticeable, but at least the metal plates covering The Leats are still in place and make it easier for prams and wheelchairs to cross the water safely.

ALL ABOARD

THE PENZANCE TO London bus rumbles into Boscawen Street, *c*.1910. Surely all those people are not waiting to get on! Perhaps the men with the ladders are trying to get close enough to the windows of the Red Lion to clean them. The bus is a Lancashire-registered Leyland with solid tyres, so it could be a long and bumpy ride – and, if one were a passenger on the open-top deck, very draughty! The car park attendant's hut was in use at this time as a rest area for taxi drivers but did not look very elegant outside the prestigious Red Lion.

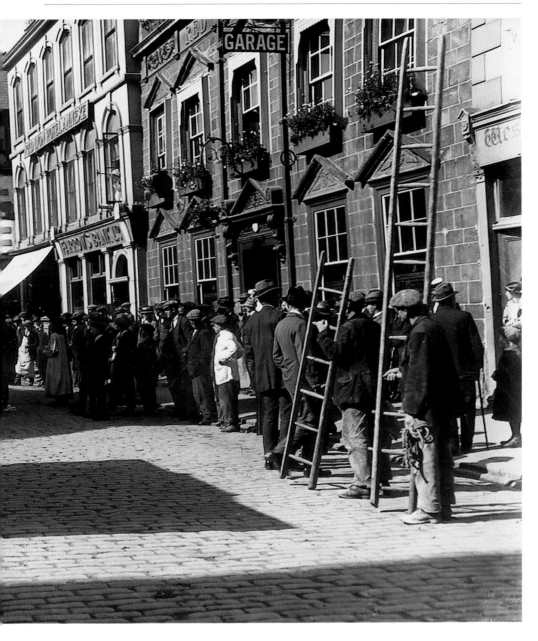

TODAY, WESTERN GREYHOUND is one of the bus companies that provide a service in the county. This bus has just arrived in Boscawen Street and the driver was about to change the number to 597 and set off for Newquay. Queues still form as people wait for their bus to arrive but at least these days they can window shop while they wait outside British Home Stores. The driver has been careful not to block the slab across the channel for The Leat as this is necessary for prams, wheelchairs etc. Although it is early in the season, the town is already decorated with hanging baskets full of flowers.

THE WILLIAM IV

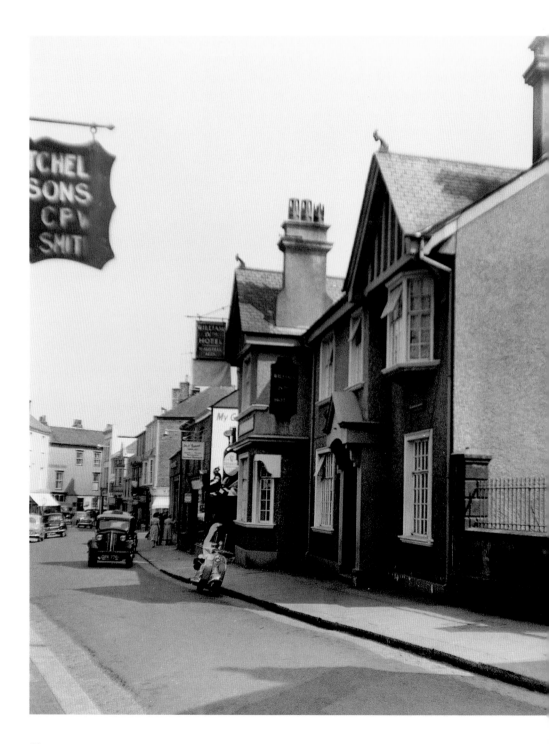

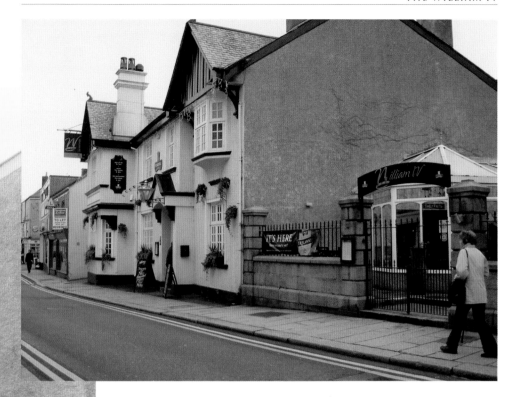

ONE OF THE oldest streets in Truro, Kenwyn Street is where the Dominican friars settled when they came to Truro in the middle of the thirteenth century. The pavement on the left of this old photograph had – and still has – a manhole cover set into it: this covers a well, used by the friary, beneath it. Also on the left was the blacksmith's shop of Fred Mitchell and his sons Fred and Byryn. The yard here was made of cobbles that had been laid by the monks. The William IV, snapped here in the 1960s, would have been built very close to the old burial ground of the friars. Since this photograph was taken, a variety of trees and shrubs have grown up behind the iron railings. However, they have recently been cleared away to maintain the uncluttered look of the patio area.

THE WILLIAM IV has changed little over the years, although a smart modern conservatory gives extra dining room these days. In summer the front of the building is covered with hanging baskets full of flowers and looks very attractive. Yellow lines have appeared all up the street – which is just as well, as this is now on the bus route and just one parked vehicle can cause chaos right back to Victoria Square. Just up the street, on the same side as the pub, is an alleyway called Bices Court where a millstone from the friary is set into the ground. What would the monks have thought of all this eating, drinking and merriment?

THE FAIRY BRIDGE

THE FAIRY BRIDGE was always a popular place in the park for children to visit, and two of them are posing in this photograph. Along with the fish pond at the top of the gardens, it was the main attraction. In this old view we can see St George's church and beside it the chimneys of the Carvedras Smelting Works. Victoria Park, as it is called in this view, was opened in 1898, and judging by the plants and the viaduct this picture was probably taken in around 1905. Some railway buildings are visible in the railway station at the end of the viaduct.

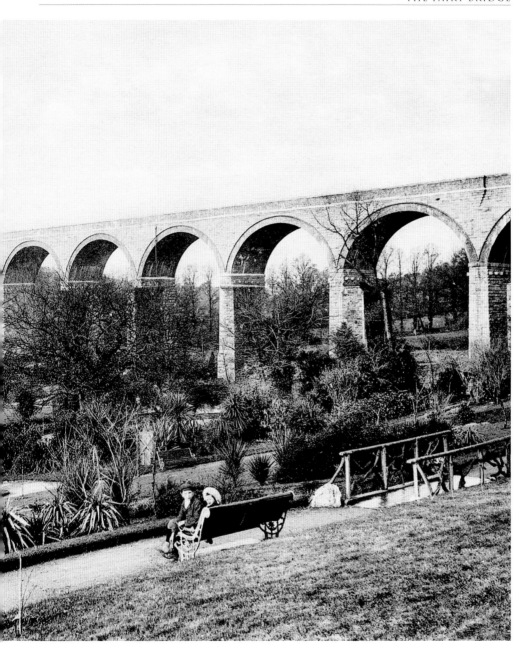

THE FAIRY BRIDGE is not quite so attractive these days as it was when it was made of wood.
However, as The Rotary Club have designated the area as a commemorative garden celebrating
their Golden Jubilee, 1922-1972, and have made a rockery and waterfall under the bridge, at least
it is a pleasant bridge to cross. The trees block much of the view but the viaduct is just visible and
actually has a Great Western train on it, which is on its way to the station. The gardener is clearing
up some dead wood and the spring flowers are looking very attractive.

LOWER END OF LEMON STREET

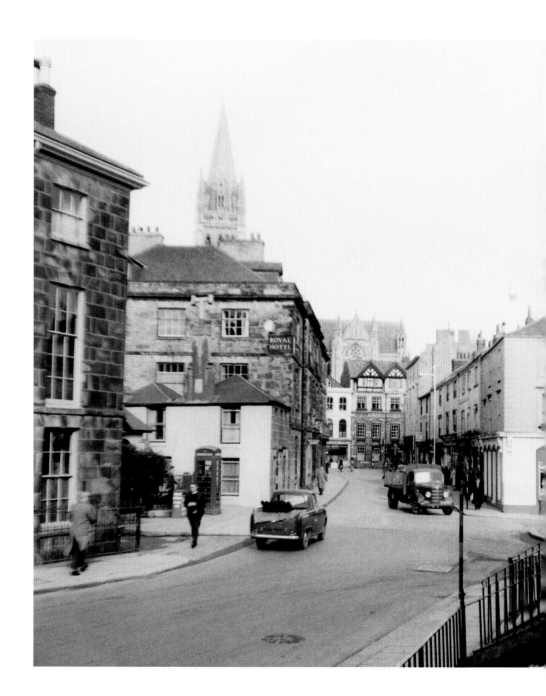

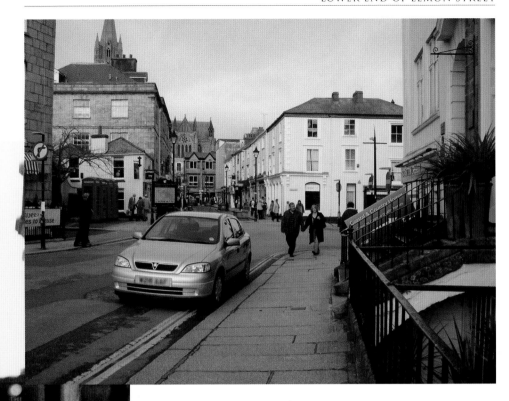

IN THIS VIEW of the end of Lemon Street, at the point where it joins
Lower Lemon Street, the road seamlessly joins the two, but until 1926
this is where Lemon Bridge was situated. The bridge joined the two areas
and replaced stepping stones. This old lorry, captured during the 1960s,
is turning down to Back Quay. The old building behind it is The Red
Lion. It is amazing to think that the old quay is still there below the road
and what diverse traffic has used it over the years. Elephants and camels
have paraded along it, ships have been unloaded and queues have
waited patiently for the re-opening of Gill's store.

IT IS A surprise to many people that Lemon Street, known as 'the
finest Georgian street west of Bath', was built piecemeal with no
town planning. A house here, a public house there, a gap to be filled
in elsewhere – but the end result is a beautiful Georgian street. One
summer evening in 2011, the peace of Lemon Street was shattered as
a massive group of drummers marched down to The Piazza. There they
were greeted by a large crowd eagerly awaiting the unveiling of the large
statue of 'the drummer'. After speeches by the mayor and the sculptor,
the unveiling was performed by someone who grew up in Truro and
who was possibly the main attraction of the evening: Roger Taylor, of
Queen fame.

THE BANDSTAND

VICTORIA GARDENS WAS the tribute paid to Queen Victoria in the sixtieth year of her reign and was opened on 20 June 1898. It is on a steep site but the pathways and flowerbeds lead the walker on to the level area where the bandstand is situated. Down below, in the pathway through The Leats, a regular thumping can be heard from the ram that pumps the water up to the fish ponds that are at the top of the gardens. There is an attractive park keeper's house overlooking the bandstand and it must be one of the few houses in Truro with such magnificent surroundings.

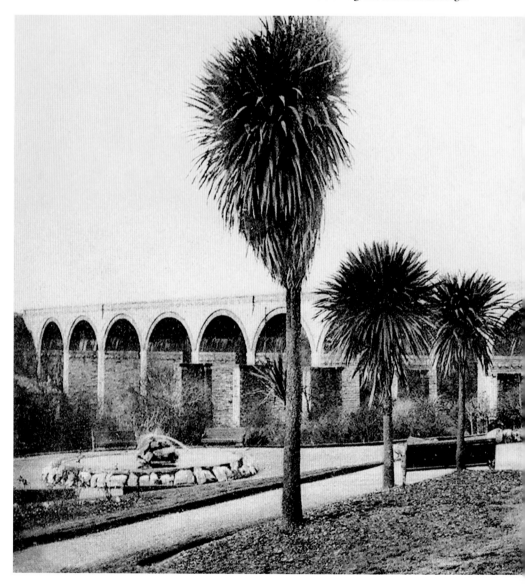

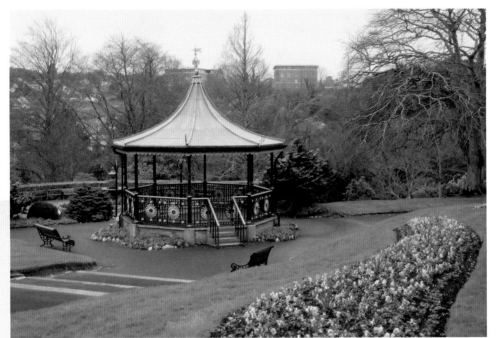

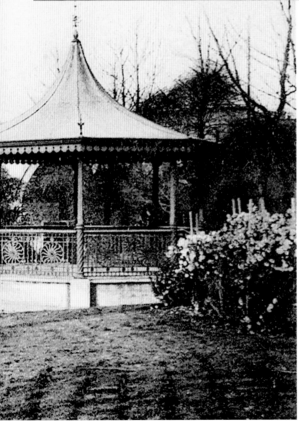

THE BANDSTAND HAS been a popular place ever since it was first built and concerts from both the Truro City Band and visiting bands are very well attended in the summer months. The palm trees in the photograph on the left – taken when the park had been in existence for eleven years – have gone now, but other trees have taken their place, so much so that the viaduct is hidden from view in this winter picture. Two new blocks of flats built alongside the railway dominate the skyline but a piece of old Truro can be seen beside the bandstand: the fountain, moved to the middle of the lily pond from Boscawen Street in 1937. Just outside the gardens is the other small park known as The Waterfall Gardens and round the corner, under the viaduct, are the Dreadnought Playing Fields, to amuse the children of Truro.

If you enjoyed this book, you may also be interested in...

Truro

CHRISTINE PARNELL

This fascinating collection of over 260 old photographs provides a glimpse into the life of the city from the last century to recent times. The photographs all come from private collections and few, if any, have been published before. This collection includes many of Truro's well-known and beautiful landmarks including elegant Lemon Street, the cathedral, the rivers and the bridges. These treasured pictures will bring back memories to be enjoyed by all who know and love this beautiful Cornish city.

9780752410265

Paranormal Cornwall

STUART ANDREWS & JASON HIGGS

The mystical county of Cornwall, rich in folklore and legends, is also home to an array of paranormal activity. Drawing on historical and contemporary sources, this selection includes sightings of UFOs and big cats, ghosts, sea monsters, piskies and many other bizarre phenomena in the county. Accompanied by eyewitness interviews, press reports and previously unpublished investigation accounts carried out by the authors, this incredible volume will invite the reader to view the county in a whole new light.

9780752452616

Cornish Folk Tales

MIKE O'CONNOR

The ancient land of Cornwall is steeped in mysterious tradition, proud heritage and age-old folklore. Before books were widely available, wandering 'droll tellers' used to spread Cornish insight and humour to all parts of the Duchy – exchanging tales for food and shelter. Anthony James was one such droll teller, and this collection follows him as he makes his way around Cornwall one glorious summer.

9780752450667

A Grim Almanac of Cornwall

JOHN VAN DER KISTE

For those with an interest in the darker side of history, *A Grim Almanac of Cornwall* is a day-by-day catalogue of 365 ghastly tales from around the county. Read about the leaders of the 1497 rebellion, who fought for their county only to be hanged, drawn and quartered at Tyburn; the fatal gunpowder explosion near Truro in 1864; and the horrifying case of Henry Mortimer, who killed his wife, four children and himself at Saltash in 1901. Generously illustrated, this chronicle is an entertaining and alternative history of Cornwall.

9780750951319

Visit our website and discover thousands of other History Press books.

www.thehistorypress.co.uk